CROMER & SHERINGHAM

THROUGH TIME

Michael Rouse

AMBERLEY PUBLISHING

First published 2010

Amberley Publishing
Cirencester Road, Chalford
Stroud, Gloucestershire, GL6 8PE

www.amberley-books.com

Copyright © Michael Rouse, 2010

The right of Michael Rouse to be identified as the
Author of this work has been asserted in accordance
with the Copyrights, Designs and Patents Act 1988.

ISBN 978 1 4456 0000 0

British Library Cataloguing in Publication Data.
A catalogue record for this book is available from
the British Library.

Typeset in 9.5pt on 12pt Celeste.
Typesetting by Amberley Publishing.
Printed in the UK.

Introduction

He who would Old England win
Must at Weybourne Hoop (Hope) begin.
Cromer crabs, Runton dabs,
Beeston babies, Sheringham ladies,
Weybourne witches, Salthouse ditches

<div align="right">Old Norfolk place-names rhyme</div>

A wild coast, small villages, the haunt of fishermen and smugglers, crumbling cliffs, lost settlements – the stretch of the Norfolk coast from Weybourne to Mundesley had it all. It also had large landowners, like the Upchers at Sheringham Hall, the Bond Cabbells at Cromer Hall and Lord Suffield at Gunton Hall, who all had hundreds of acres of land on and around the coast. They could see the benefits of cashing in on the new fashion for taking the sea air and the sea-water cures.

Royal patronage at Brighton in 1783 from the Prince of Wales, later to become King George IV, had established the town and set a fashion for the future. By the end of the eighteenth century, seaside towns like Scarborough, Brighton and Margate had developed as fashionable places, just as the Spa Towns like Bath and Harrogate had before them.

Places with good access to large inland towns, especially London, began to develop and prosper. Southend-on-Sea became increasingly popular during the nineteenth century. The Norfolk coast, however, was more inaccessible. It was the Great Eastern and the Midland & Great Northern Railway companies who would open up the Norfolk coast in the second half of the nineteenth century.

Coastal erosion, crumbling cliffs, shifting sandbanks and shingle ridges meant that the Norfolk coast was changing all the time. Once prominent Glaven ports like Wiveton, Blakeney, Cley and nearby Salthouse were becoming increasingly cut off from the sea. The possibility of a visitor and holiday industry brought them some hope of economic prosperity.

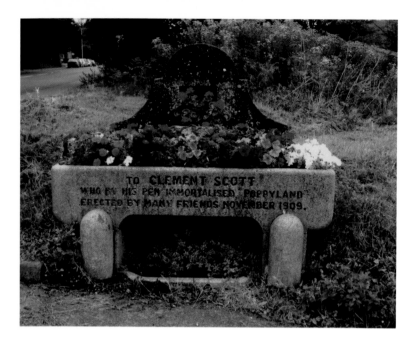

Even after the arrival of the Great Eastern Railway at Cromer in 1877, the town had not developed as quickly as hoped. The visitor figures were not as high as anticipated, partly because the service via Norwich was not particularly quick or convenient and partly because the station was outside the town. The Bond Cabbells at Cromer Hall had huge investments at stake, as did others. In 1883 the Editor of the *Daily Telegraph*, probably at the instigation of the Great Eastern Railway Company, sent Clement Scott, his theatre critic and travel writer, to visit Cromer.

Scott left his luggage at the station and walked into Cromer and then found himself climbing up the cliff path to the east. 'So great was the change from the bustle of fashion to this unbroken quiet that I could scarcely believe that I was only parted by a dip of coastline from music and laughter and seaside merriment; from bands and bathing machines...' He came across the old ruin of Sidestrand church, with its tower left on the cliff top as a landmark for shipping. From there he strolled through the fields of poppies until he came across the Mill Cottage and the 'Maid of the Mill', the shy nineteen-year-old Louie Jermy.

Scott stayed at Mill Cottage, wrote about his experiences in articles, and then in the book *Poppyland*, and so the romance of this part of the Norfolk coast was born. Scott frequently returned and in later years he would spend New Year's Eve at the old church tower, which he immortalised in 'The Garden of Sleep'. Scott died in 1904 and in 1909 his friends raised a memorial trough-like fountain to him at the junction of the Northrepps and Overstrand roads.

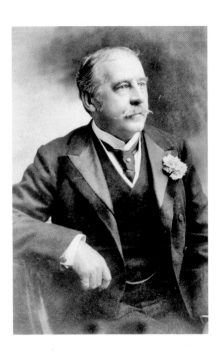

Many guests from fashionable society enjoyed Louie Jermy's hospitality and her famous blackberry puddings, but the First World War changed everything. The military took over large sections of the Norfolk coast and officers were billeted in the Mill House. Alfred Jermy, the miller, died in 1916 and Louie was forced to leave, taking with her whatever possessions she could afford. She became something of a recluse, living in a cottage in Tower Lane. She died in 1934 at the age of seventy.

By the time of her death Poppyland was already fading, along with the Poppyland china and Poppyland perfume. Eventually Louie Jermy's cottage, like the old church tower at Sidestrand, fell victim to the sea.

This book, which is primarily about the development of the holiday industry, also covers what another writer called 'the wrong side of Cromer', although Weybourne, Sheringham and East and West Runton would hardly see themselves as that today, but for a while Overstrand was one of the most fashionable places in the country, boasting numerous millionaires with homes there.

If a changing coastline and changing fortunes have been the story of this part of the Norfolk coast, it is still the story. Some land and properties will be abandoned to the sea as indefensible against rising tides and shifting sands. The photographs taken this summer reflect some of this change and I hope capture the stunning beauty of this coast, which I love.

'Time and tide wait for no man' says the ancient proverb and nowhere is it more true than along the North Norfolk coast.

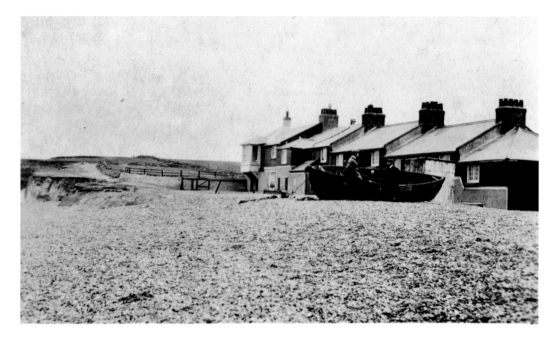

The Old Coastguard Station, Weybourne

It is said that the ancient Angles first landed at Weybourne and that Danish invaders made several raids here. The beach is so steep that large vessels can get close to the shore, thus making Weybourne convenient for any invasion. The Spanish Armada, and Napoleon, it was thought, would land here and as a result this part of the coast has always been well defended. This is where the shingle spit of Blakeney Point meets the coast. The old coastguard station has long gone.

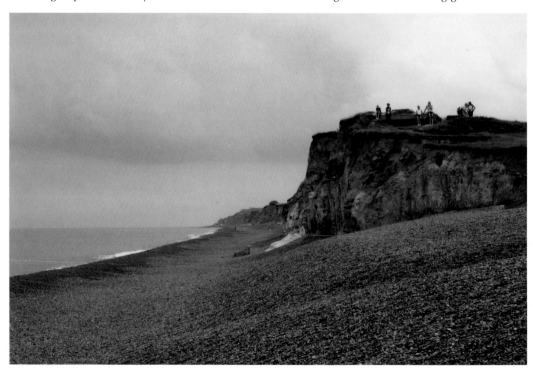

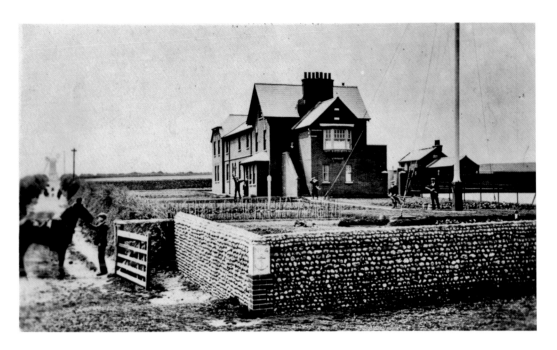

Coastguard Buildings, Weybourne

Approachable by a very narrow lane, past the 1850 redbrick tower mill, this Coastguard Station was higher up on the cliffs and replaced the beach station just before the First World War. Over the last hundred years the sea has eroded the cliffs so much that the wall has gone and it is difficult to photograph the whole building without falling over the cliff edge. During the Second World War the beach was heavily mined and there was a highly secret anti-aircraft artillery range at Weybourne Camp.

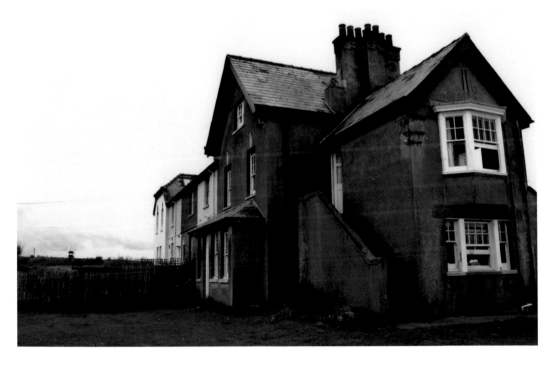

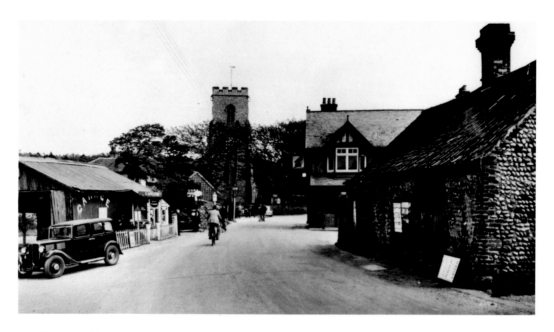

Weybourne Village

The scene has changed little over the last fifty years. This is the main coast road and these photographs are where the narrow road will take you down to the beach. At the beach there is a good-sized car park for those who want to fish, sit on the shingle bank or enjoy a bracing walk. The Muckleburgh Collection, a working military museum at the former military camp, is just to the west, as is the new terminal for the Sheringham Shoal offshore windfarm.

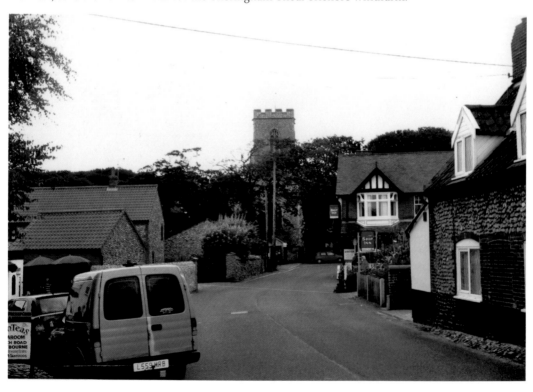

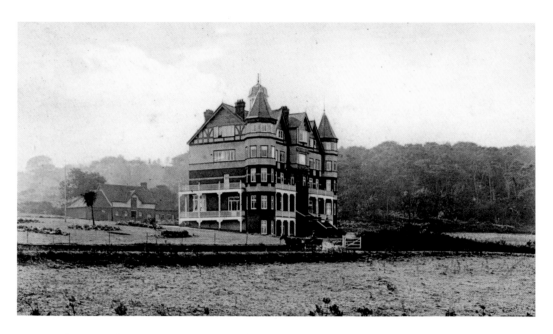

Springs Hotel

The Springs Hotel, so named because of nearby springs which were reputed to have medicinal properties, was never really successful. As the sender of the above postcard writes in about 1908: '65 of us are at a Bible School ... this is a very isolated place, a mile from the coast.' It was built in 1900 when the railway station opened nearby. The Springs Hotel was demolished around 1940, while the station has been revived by the North Norfolk Railway enthusiasts on the Poppy Line.

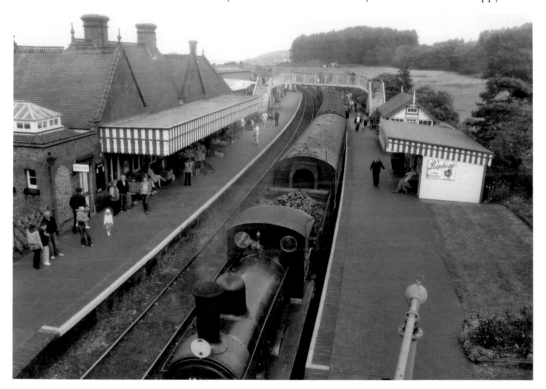

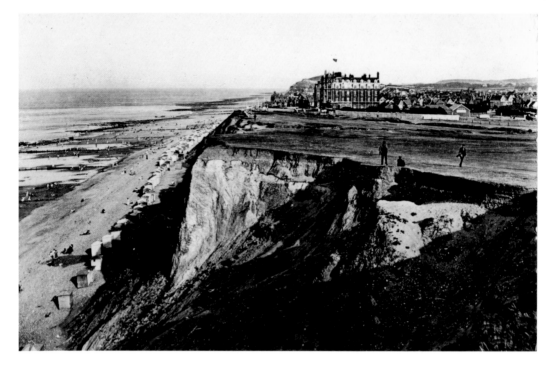

West Cliff, Sheringham

The Poppy Line runs steam trains on the five miles of track between Holt and Sheringham. Walter Rye in his 1882 *Tourist's Guide to Norfolk* described Lower Sheringham as 'a well-known lobster fishing station crowded along the edge of the cliff'. That was it! Thirty years later the Ward Lock Guide was saying: 'Changed out of all resemblance to its former self ... once a cluster of fishermen's cottages now dominated by stately and luxurious hotels...'

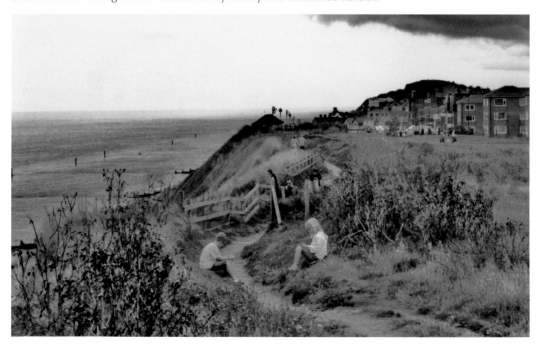

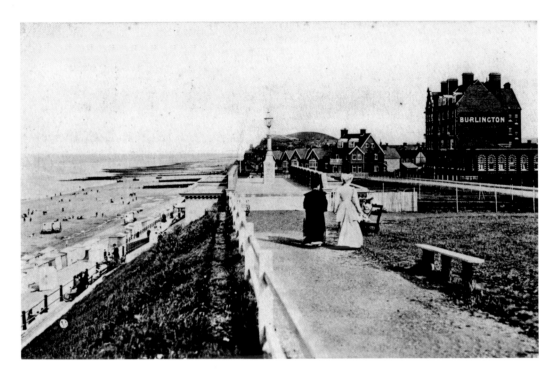

Sheringham from West Cliff

It was the railway that made Sheringham. By the mid 1890s the Great Eastern Railway Company and the Midland & Great Northern, known affectionately as the 'Muddle and Get Nowhere', had opened up much of rural Norfolk. It was the Midland & Great Northern from its hub at Melton Constable that took the line through Weybourne to Sheringham and Cromer and that had built the Springs Hotel.

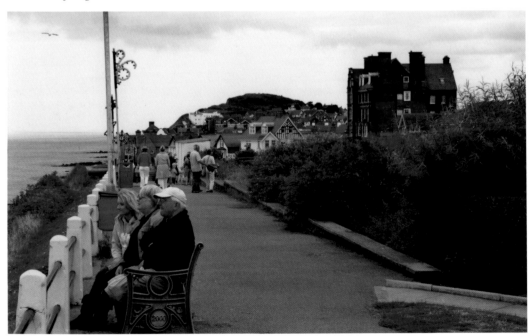

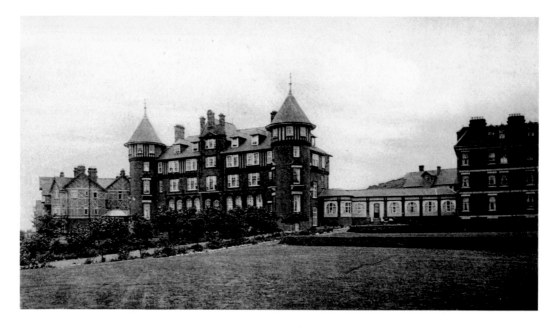

The Sheringham Hotel

A nine-hole golf course was laid out on the West Cliff in 1891 and soon extended to eighteen holes, while at the same time the impressive Sheringham Hotel, designed by George Skipper of Norwich, was opened nearby on the corner of the Weybourne and Holt Road. In 1889 the Sheringham Gas and Water Company was formed. There was also a Sheringham Development Company under the superintendence of William Marriott which undertook the drainage of the town.

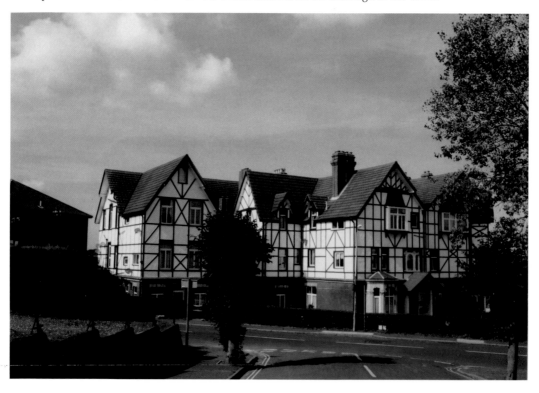

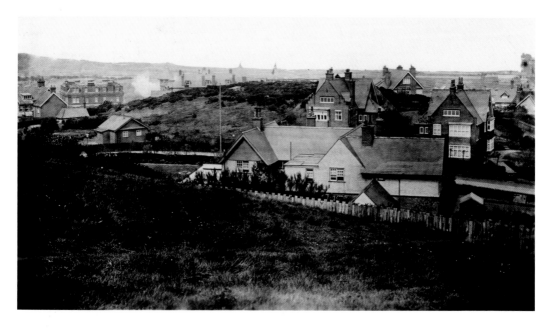

Sheringham from Hooks Hill

A seat at the top of what is known as Franklin Hill carries the plaque 'In loving memory of A. F. ... this Hill Crest was presented by her son to the town of Sheringham for the perpetual use of the public, October 1903.' On the left among the fine houses can be seen the turrets of the Sheringham Hotel, which is now the site of Sheringham Court. Today trees obscure this view but it is possible to look out to the sea over the golf course.

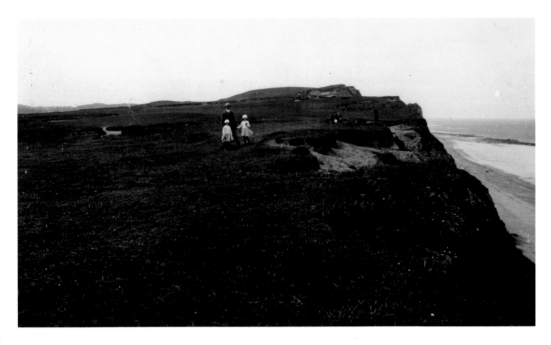

The Golf Links

Golf was a big attraction in the early days of the developing resorts and there was plenty of space along the cliff tops to lay out courses. The Sheringham course is on undulating downs and rises to a height of two hundred feet above the sea. For those playing there are marvellous views of the countryside and the coastline as far as Blakeney. The small coastguard hut on Skelding Hill is now manned by Sea Safety Group volunteers.

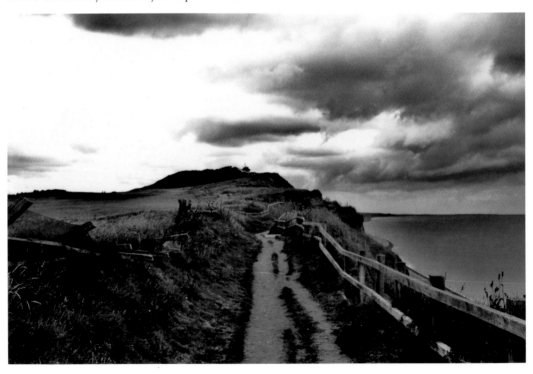

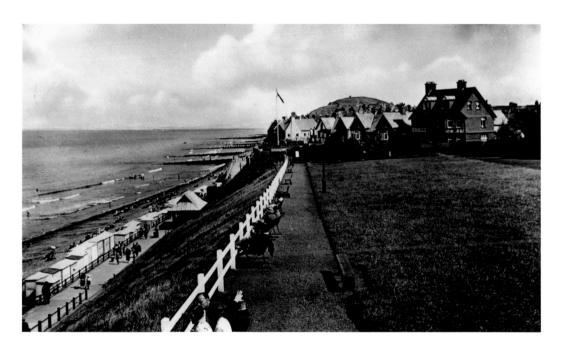

West Promenade, Sheringham

Sheringham's clifftop position gave the opportunity to develop promenades at two levels and link them by steps. Along the top of the west promenade were gardens and the fine hotels. Down below was the promenade with the beach huts. By 1906 in *The Bystander* Eric Clement Scott, under the heading of 'A New Seaside Resort', described Sheringham as 'the paradise of the potterer'. He also refers to the resort growing up on 'the wrong side of Cromer' and calls Sheringham 'a friendly rival of Overstrand'.

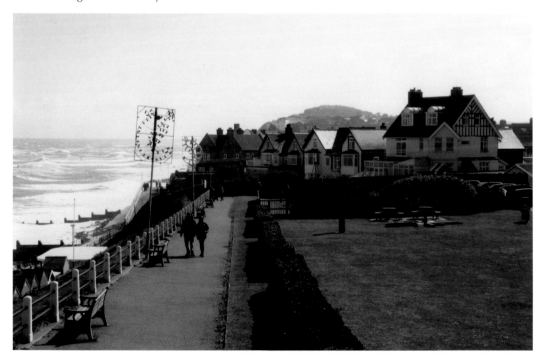

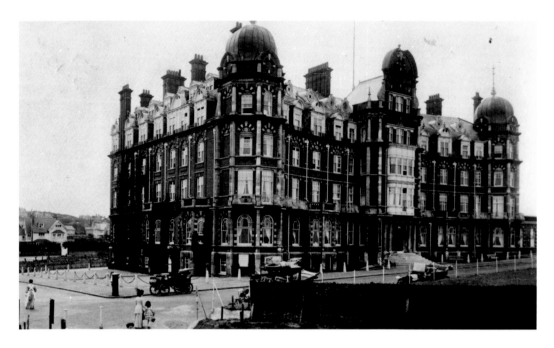

The Grand Hotel, Sheringham

In 1898 the magnificent Grand Hotel designed by H. J. Green of Norwich opened on the Leas on the West Cliff. It looks a well-planned development with the Boulevard leading to St Nicholas Gardens and then going on to a T-shaped esplanade. The Burlington Hotel followed the next year. The esplanade had it own shelters, toilets and archway leading to slopes east and west to the lower promenade. Sadly the Grand was demolished in 1974. The Burlington, however, still stands.

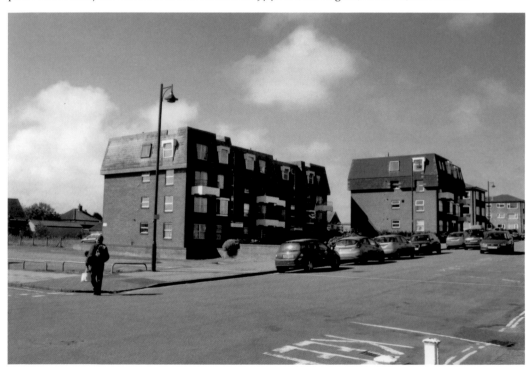

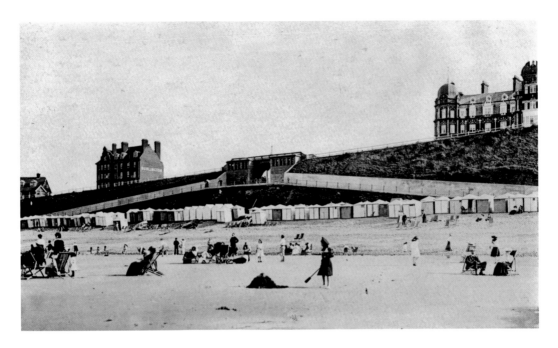

Burlington and Grand

Both hotels are prominent on the cliff top in this lovely Edwardian photograph. Strangely, although someone has written where they were staying and the date from 22 August to 12 September 1908, there is no message. This postcard would date from a time when those who wanted others to know that they were there would place a notice in the local newspaper. Members of many of the wealthier families would stay for 'the Season' and be seen promenading beside the sea.

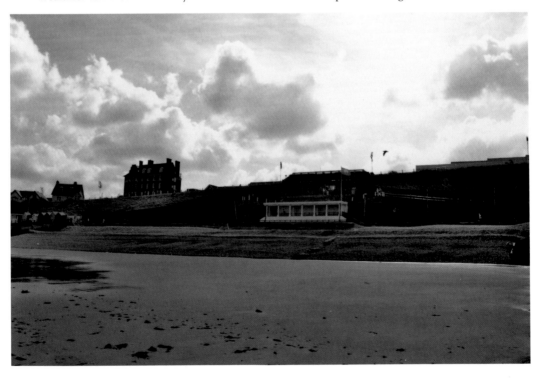

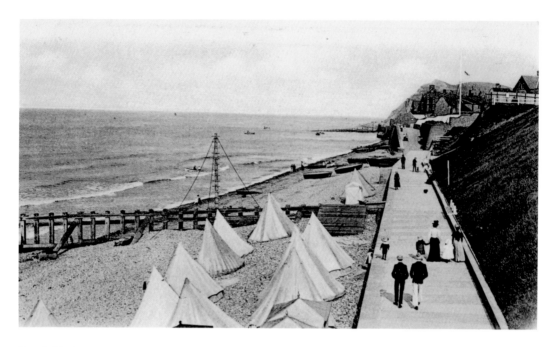

Beach Tents

In 1883 Robert Thomas Grimes Pegg, known as 'Godfather' Pegg, one of the Sheringham fisher community, recorded thirty visitors that summer. He was one of the early holiday pioneers: noticing visitors undressing on the beach, he supplied five tents for hire. This number increased to sixty bell tents before he provided lockable huts. He held the beach hut and beach chair monopoly for fifteen years as well as giving boat trips and teaching swimming.

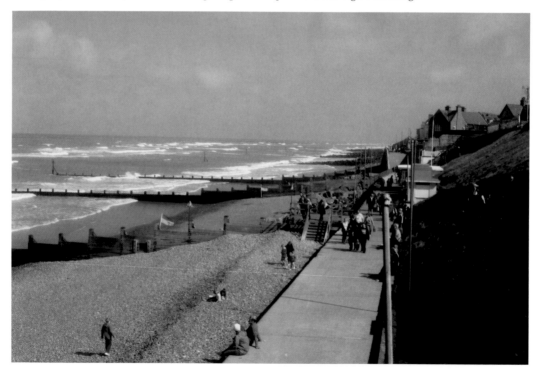

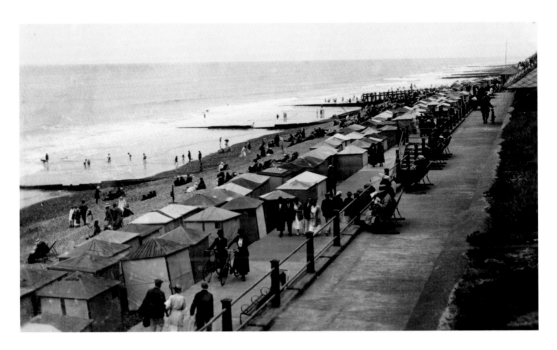

Sheringham Sea Front

Winnie wrote in September 1922 to 'Mother Darling' from Victoria House, 'We get a fair amount of rain, but it has not kept us in ... We are the only two visitors now but still we enjoy ourselves and have music every evening.' She asks her mother to 'phone and 'ask Dad to lend me £2.00 please as I shall not get my money in time next week and I'm a bit short'. By the 1920s the huts had become a double row along this stretch.

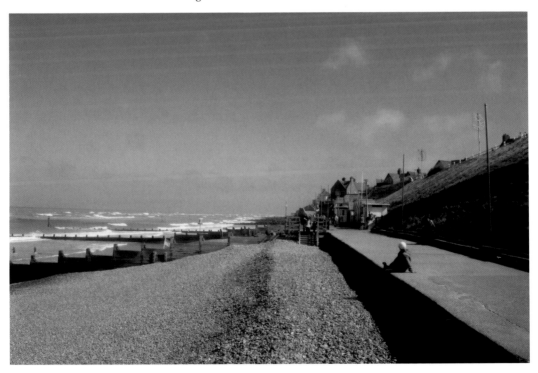

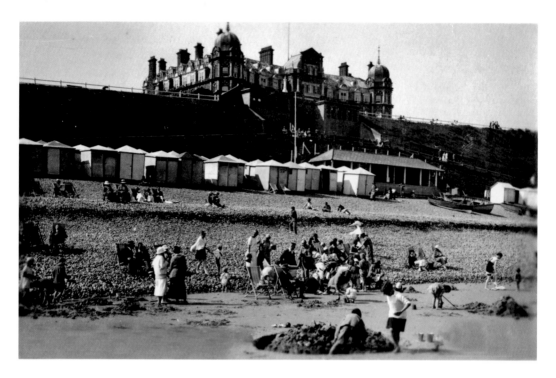

West Beach and Grand Hotel

July 1929: 'We are having a grand time down here, lovely weather.' A photograph that captures the essence of the Sheringham holiday between the wars. The Grand Hotel dominates the cliffs, the rows of beach huts, the shingle ridges and the sand at low tide. When the sea does retreat, the beach at Sheringham has been designated a Blue Flag beach and is clean and perfect for sandcastles.

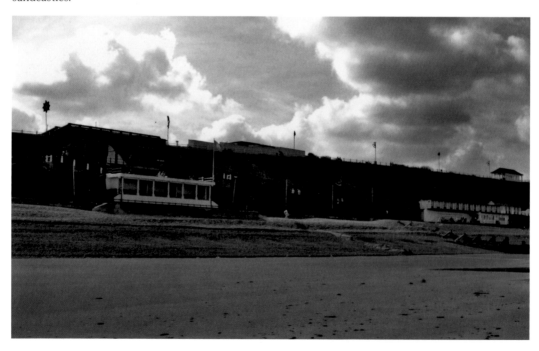

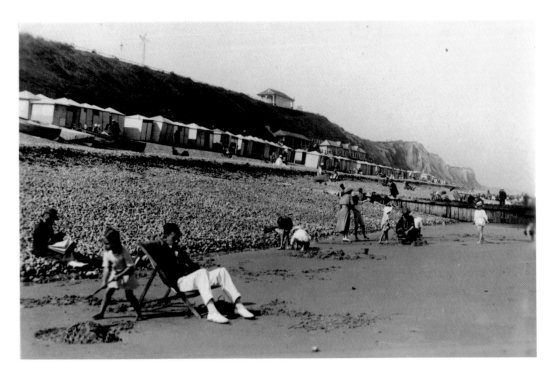

Low Tide, West Beach, Sheringham

July 1931: 'Do you remember this? I have marked our hut with a cross. Have you swapped many stamps? I am sorry that you did not get a prize at the sports. Much love from Daddy.' We can see the row of beach huts stretching the whole length of the promenade and some young and old making the most of the beautiful sand. The rigidity of the young man, very dapper in blazer, white trousers and white shoes, would suggest he is posing in the deckchair for the photographer.

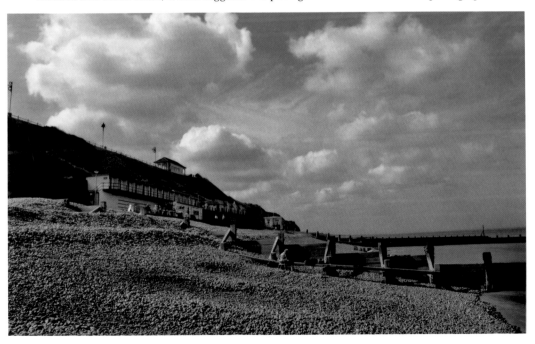

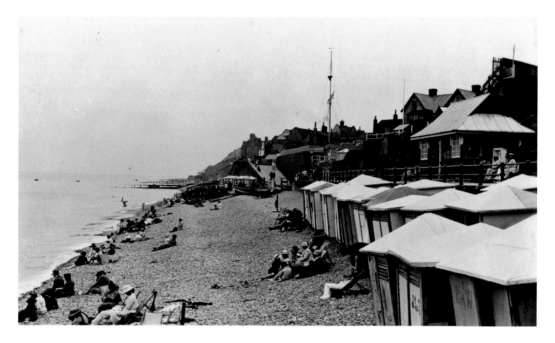

The Shore, Looking East

Another beautiful photograph from a similar period. Everyone is wearing a hat. The huts lean on the shingle ridge just below the promenade. The flagpole at the coastguard station can be clearly seen. The view today is very different with the large rocks having been brought in to line the shingle below the promenade. The modern huts are now at the back of the promenade. The red and yellow flag marks one end of the bathing area, while the lifeguards are watching from the yellow hut on the promenade.

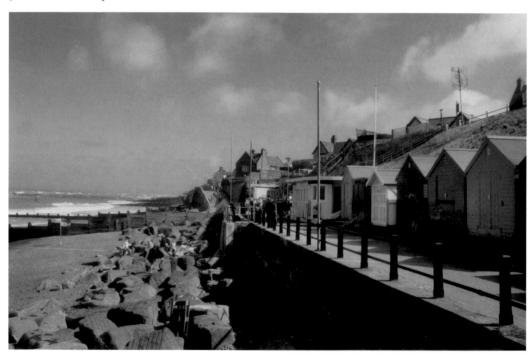

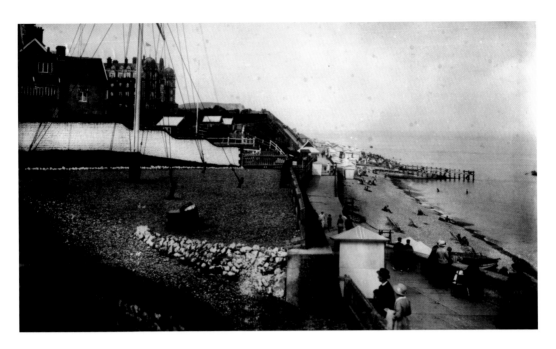

Promenade from Coastguard Station
Occupying a prominent position high on the cliff in the centre of the promenade close by, the Coastguard Station commanded clear views of the coast. This is an early 1920s photograph. HM Coastguard withdrew visual watch in 1994. The nearest Coastguard Rescue Co-ordination Centre is at Great Yarmouth. The modern photograph is from the Whelk Coppers Tea Rooms.

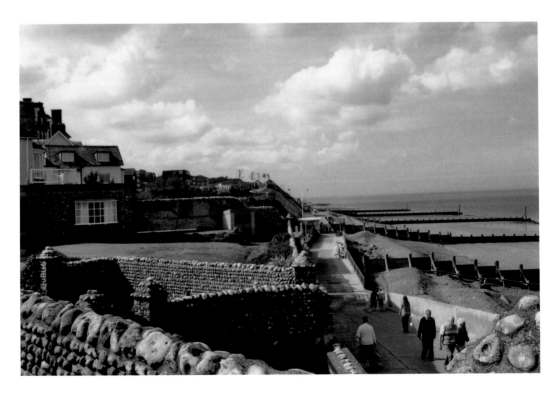

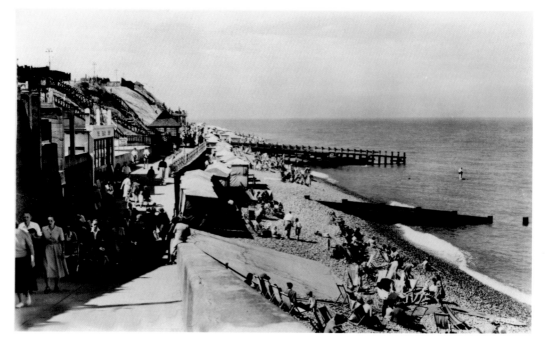

West Promenade

A later but similar view, only taken from lower down on the promenade. A typical holiday photograph showing the rows of beach huts with many people relaxing in deckchairs on the shingle banks while others climb the slope under where the Coastguard Station stood. The distinctive shelter with the gabled roof has now been replaced by a flat-roofed lifeguard station.

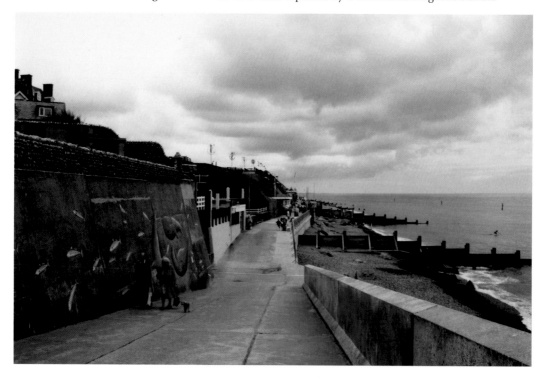

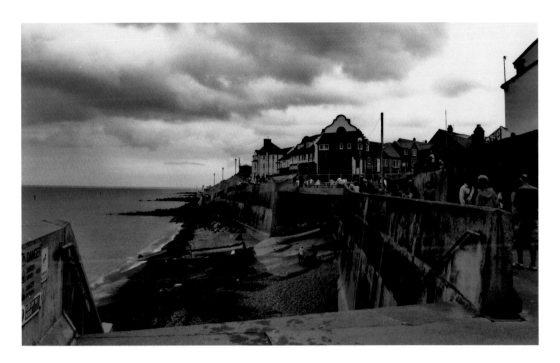

Fishermen's Slope

Probably the same photographer on the same day in the mid 1950s has turned to look towards the East Cliff. His view includes the bridge over the Fishermen's Slope. It is a view that doesn't appear to have changed much over fifty or sixty years. The large rocks on the beach against the sea wall are again noticeable. There is now a lifeboat museum at the top of the Slope.

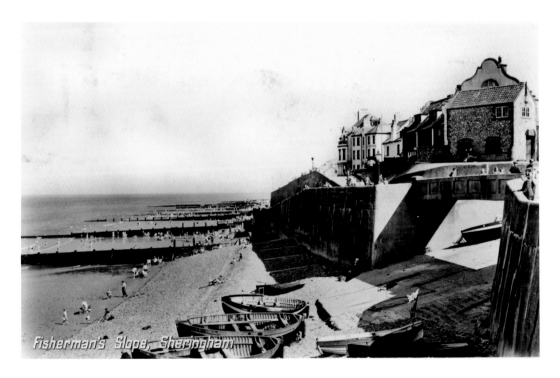

Fisherman's Slope, Sheringham

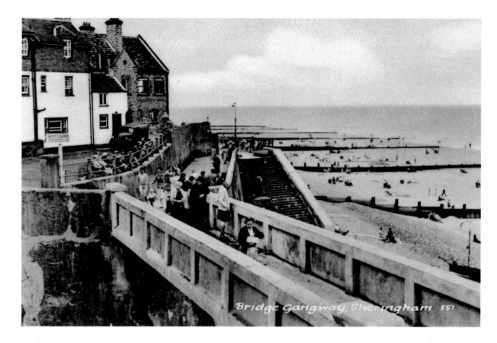

Bridge Gangway

The Fishermen's Slope was where the lifeboat was stationed. For many years Sheringham had two lifeboats. The *Henry Ramey Upcher* was given by his widow in 1866 and from the 1880s the Royal National Lifeboat Institution also provided a lifeboat. In 1879 the Two Lifeboats Coffee House was opened. The *Henry Ramey Upcher* lifeboat between 1894 and 1935 had a 28-man crew and saved over 200 lives. The spectators were watching demonstrations by Newfoundland rescue dogs for the 2010 Lifeboat Day.

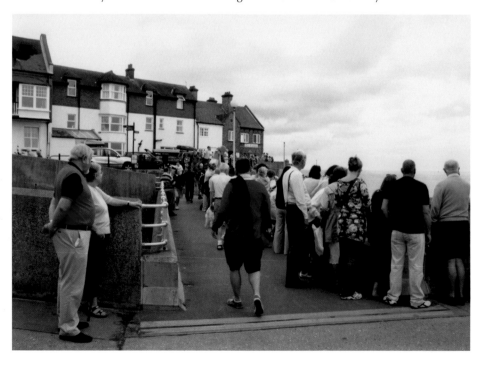

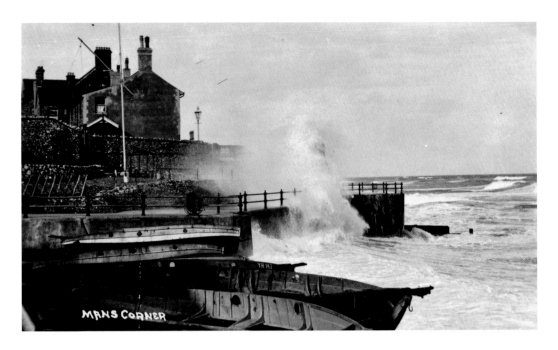

Boatman's Corner

A reminder of the force of the sea, if one was needed, on this part of the coast. Here was where the lifeboat was launched by the volunteers, often in seas worse than this. The morning of August Bank Holiday Monday 2010 saw the red warning flag flying. A strong wind is blowing and a grey sea is crashing against the rocks and the promenade. They say Skegness is 'bracing' – so is Sheringham on such a day.

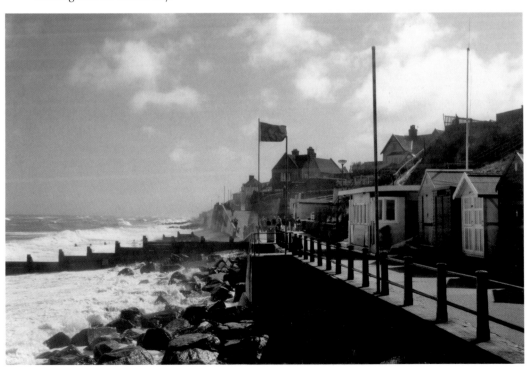

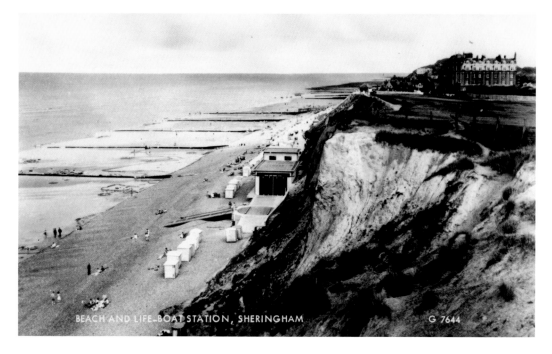

BEACH AND LIFE-BOAT STATION, SHERINGHAM G 7644

Beach and Lifeboat Station

The current lifeboat house, replacing the one at Fishermen's Slope, was opened in 1936 at the West Cliff end of the promenade. It now houses an inshore lifeboat *The Oddfellows* after the Manchester Unity Order of Oddfellows who donated the cost. It is an Atlantic 85 rigid inflatable boat. Like all lifeboats it is manned by volunteer crew and continues the noble tradition of saving lives in peril on the sea.

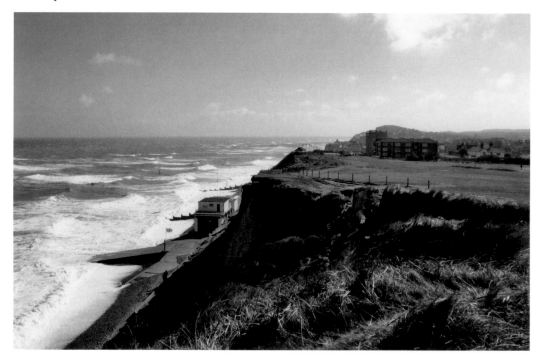

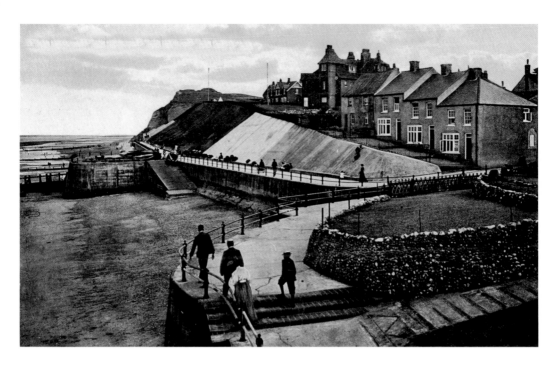

East Cliff and Promenade

There is variety to Sheringham's promenade, and where the Beach Road comes down to the water there has been considerable change since Edwardian times. New shelters and new steps now lead up to a clifftop car park with a shop and a first floor café. Some of the houses are easily recognisable while at the top of the cliffs modern flats and new houses have replaced the old. This is now a busy and popular section of the front.

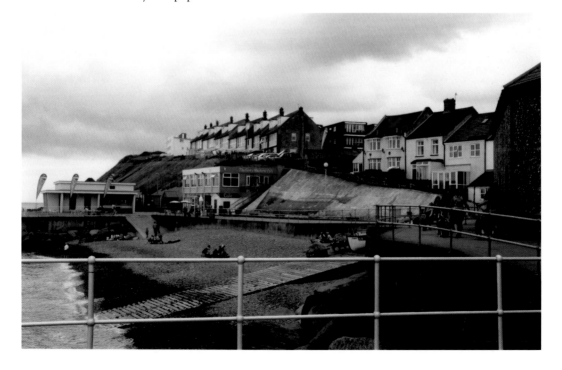

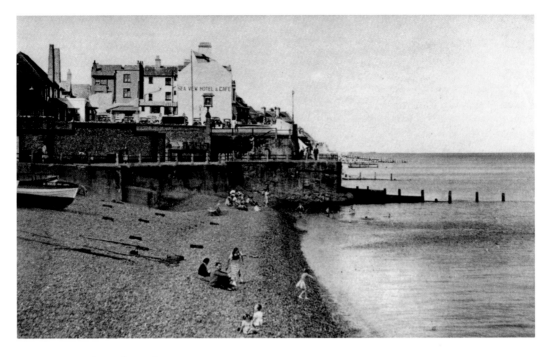

East Promenade and Beach

Looking back at the same scene, the Mo, the striking new museum with its observation tower, has been built. The £1.1 million project opened Easter 2010 and is billed as 'a place of people and boats'. The museum is run by volunteers and is open from February to the end of October. The viewing tower will open in 2011 and should give some stunning views not just of the coast but also the new Sheringham Shoal offshore windfarm.

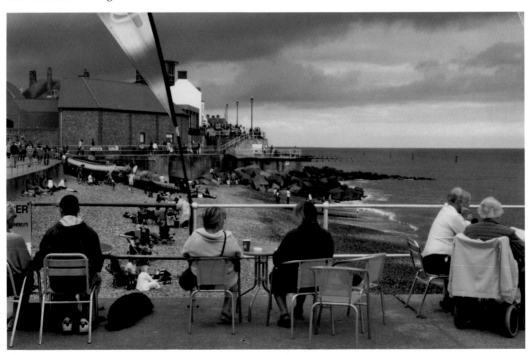

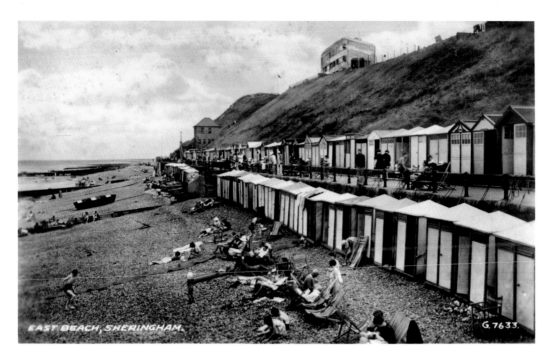

EAST BEACH, SHERINGHAM.

G.7633.

East Beach and Cliff

The row of brightly coloured beach huts still stretches down the promenade under the cliffs towards the old cloakroom and steps to the cliff top at the far end. The sea defences mean that it is no longer possible for there to be a row of huts along the beach.

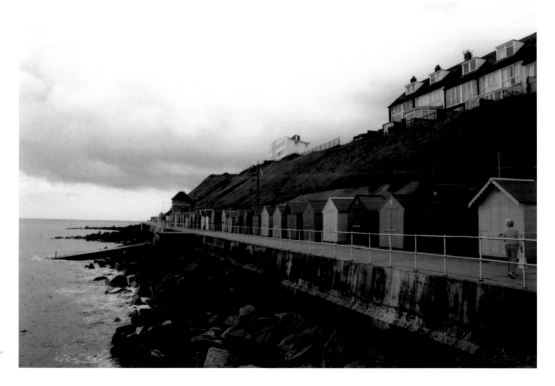

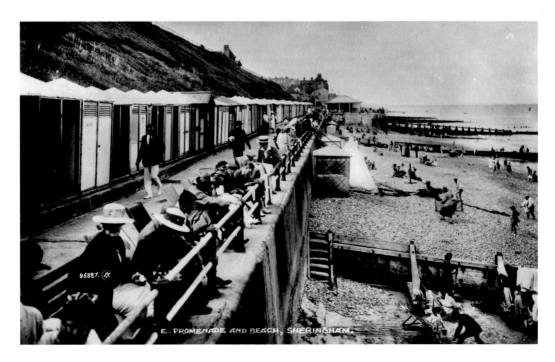

E. PROMENADE AND BEACH, SHERINGHAM.

East Promenade and Beach

Both photographs were taken on a summer's day from a very similar position, but showing a marked difference over the eighty or so years. The beach certainly looks less welcoming with the large sea defences piled up against the promenade. Perhaps modern holidaymakers are not so content just to sit and watch the sea and enjoy the fresh air as visitors did in the early days.

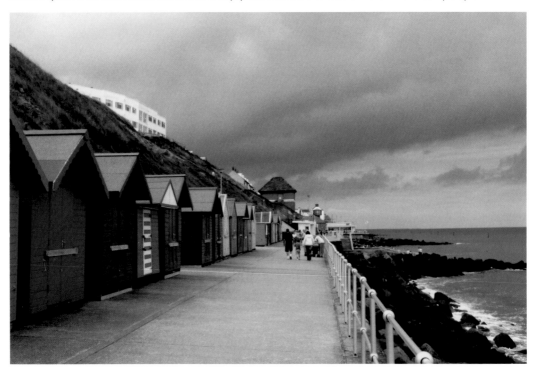

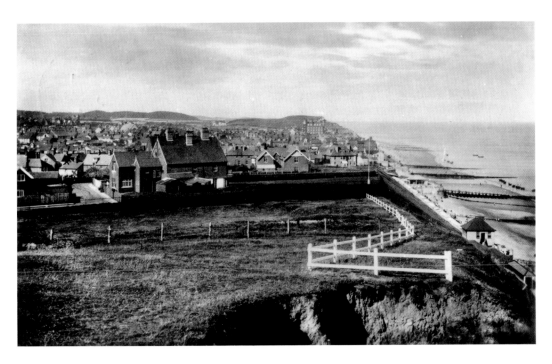

Sheringham from the East
July 1924 and the senders have put little crosses to mark the house where they are staying on Cliff Road: 'we have a little balcony and can see the sea quite well. Yesterday was a top hole day.'

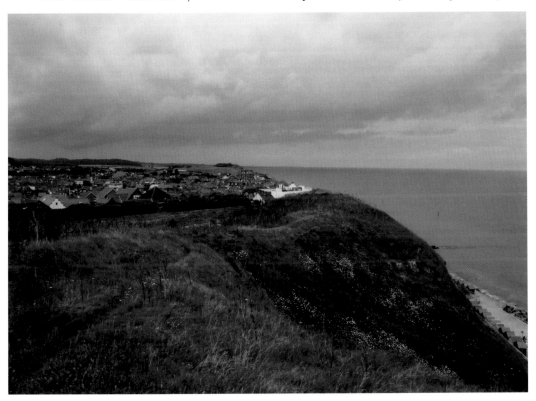

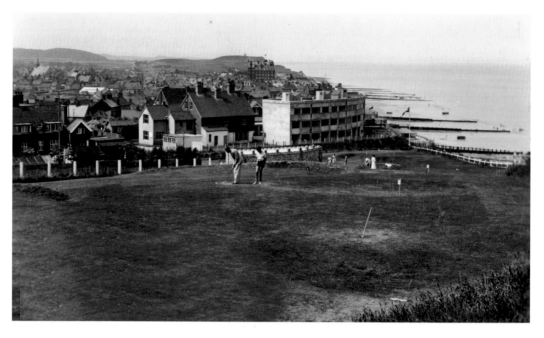

Miniature Golf Course

Probably mid 1930s and the miniature golf course has been opened and the Art Deco Queen Mary House apartment block has been built. Does anyone ever play mini golf or crazy golf other than on holiday?

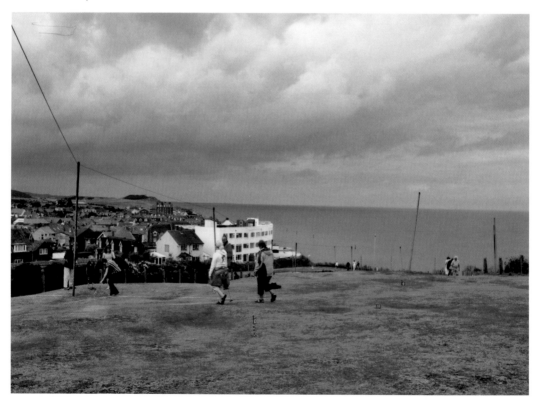

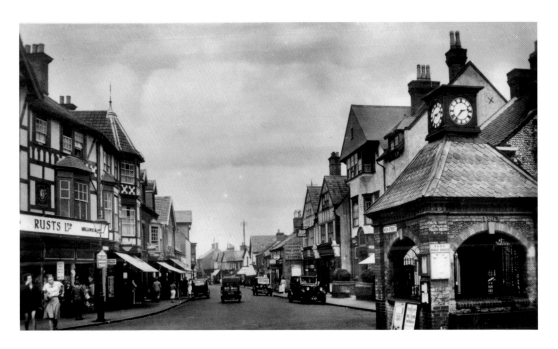

High Street, Sheringham

Photographed in about 1947 and today, the High Street retains most of its features but has added many more cars and attempts to direct and manage them. It is a busy, lively high street with a good mix of shops. The old town reservoir, built in 1862, is on the right, the old horse trough has gone, but the clock presented by Mary Pym as an Easter gift in 1903 is still there.

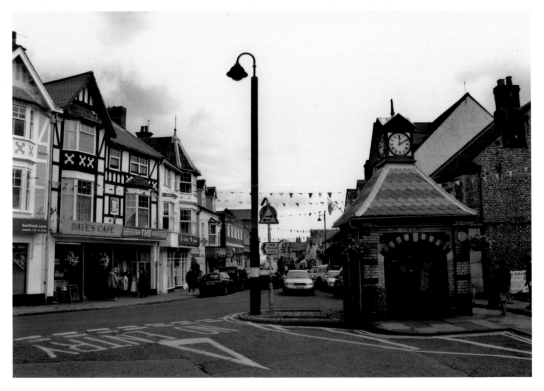

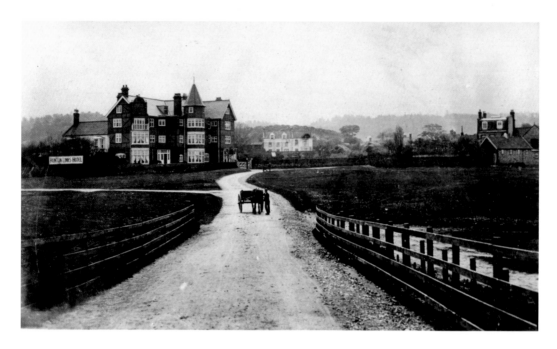

West Runton

Eric Clement Scott in 1906 was also full of praise for West Runton 'the prettiest spot around' and particularly liked the golf course. The Runton Links Hotel was built in 1899, close to the railway station. It is set in thirty-five acres of beautiful countryside. Taken over by the War Office in 1940 as a training area, some land was sold and when the hotel reopened in 1950, it was with a nine-hole course. Both the hotel and the railway, on the Bittern line, are still open.

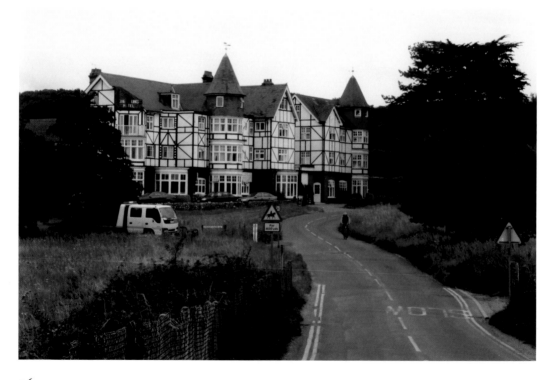

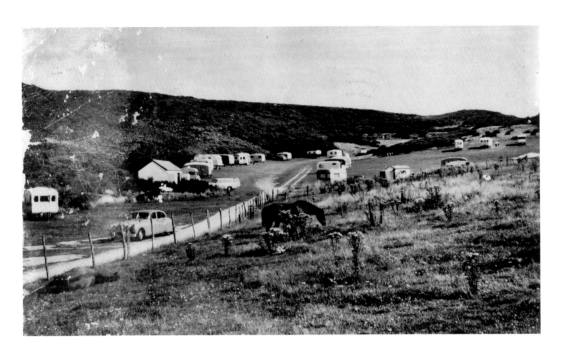

West Runton Caravans

Both West Runton and East Runton are hugely popular with caravanners and numerous sites occupy the cliff top. West Runton station was on the Midland & Great Northern line between Sheringham and the Beach Station at Cromer. One of West Runton's claims to fame is on a plaque attached to the Village Inn; it recalls the Pavilion that once hosted Chuck Berry, T-Rex, Black Sabbath and the Sex Pistols before its closure and demolition in 1986.

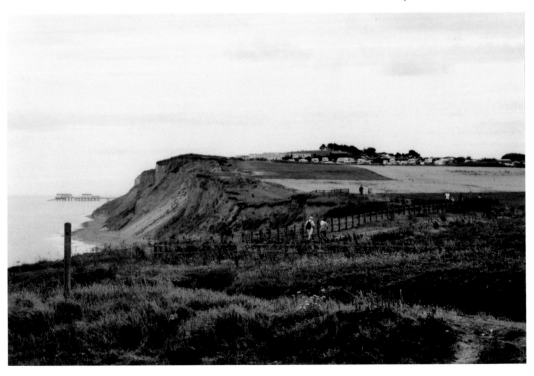

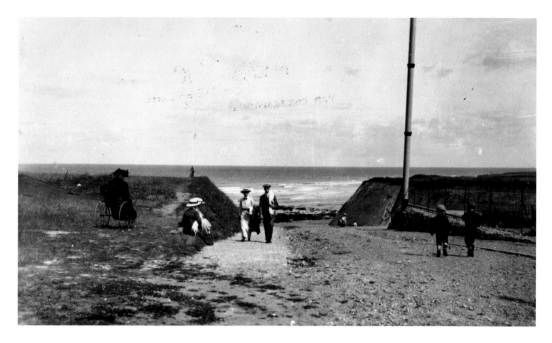

Entrance to the Beach, West Runton
The West Runton gap that leads to the beach has a large car park and a café. Once there was commercial fishing at West Runton, but because of the sea defences it is now difficult for the boats to launch or come safely ashore.

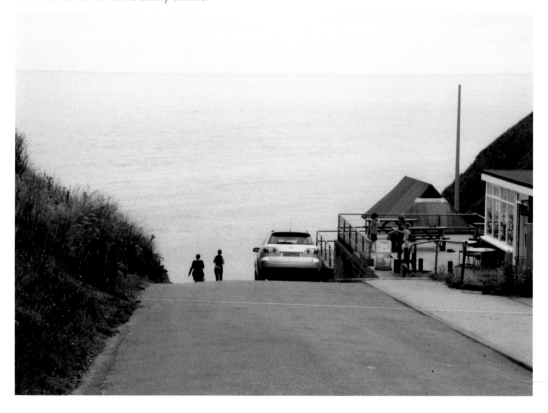

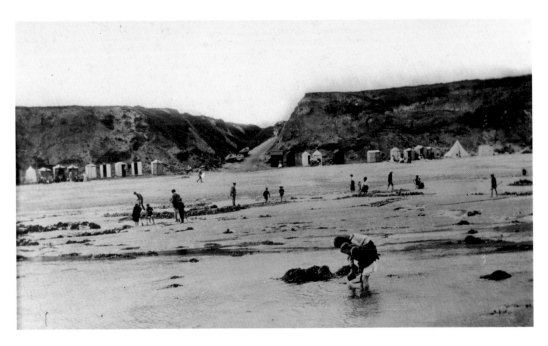

The Beach

In Edwardian times beach huts and tents lined the foot of the cliffs. Now there are strong sea defences offering a raised walkway. Caravans nestle in the clifftop hollow. When the tide goes out an area of rocks is exposed along with acres of beautiful sand and a distant glimpse of Cromer Pier.

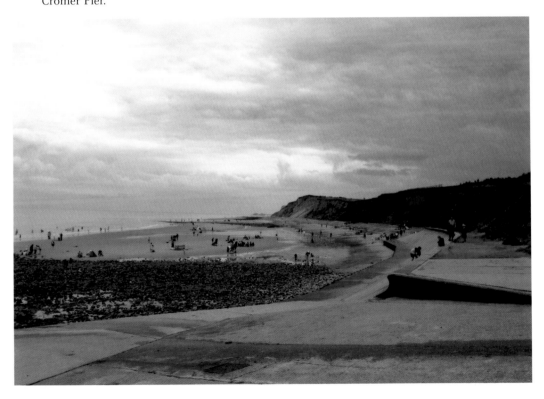

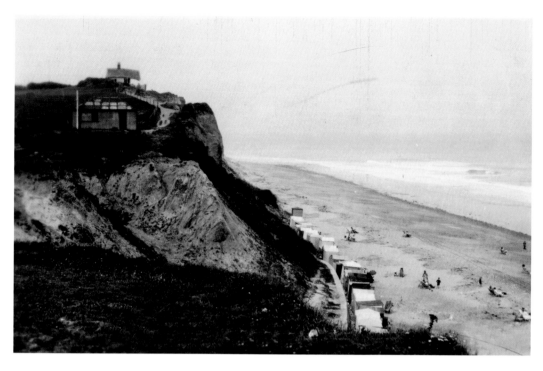

East Runton Cliffs

The growth of caravan sites since the war has transformed East Runton, but the village still has a quiet green and pond that remains relatively unspoilt. If anything there is less activity on the beach than there used to be. Certainly the rows of huts are not there. This whole section of coast has been affected by changing patterns of tides and rising water levels.

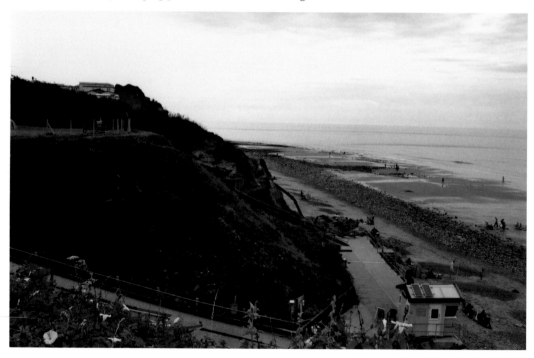

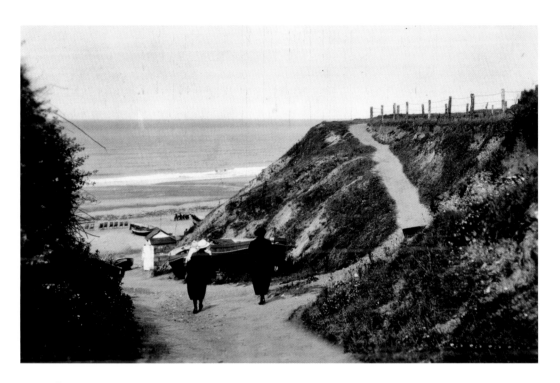

The Gap, East Runton

This was once a small fishing village and access to the beach and the sea was by this gap. A tractor and boat stand on the slope today. There are the inevitable caravan sites on either side at the top of the gap, also a public car park with toilets. It is a popular place for surfers. There is a small lifeguard post at the foot of the gap.

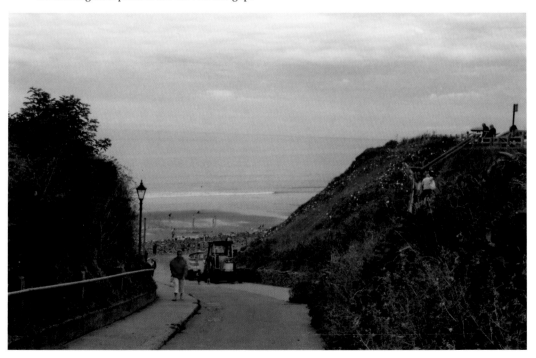

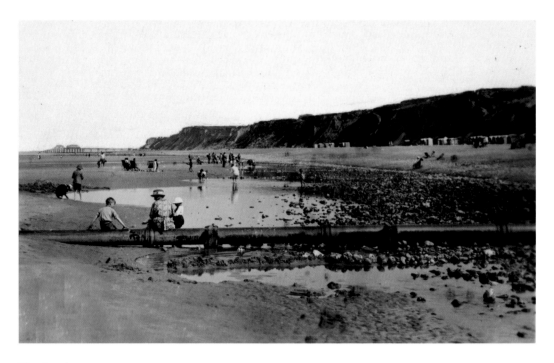

The Sands

The sewer pipe that this family is happily sitting on, as it crossed the beach and took sewage out to sea, now seems to dive down into the large rocks that give the western side of the gap a rather unwelcoming look. When the tide goes out, there are the most beautiful sands stretching as far as Cromer.

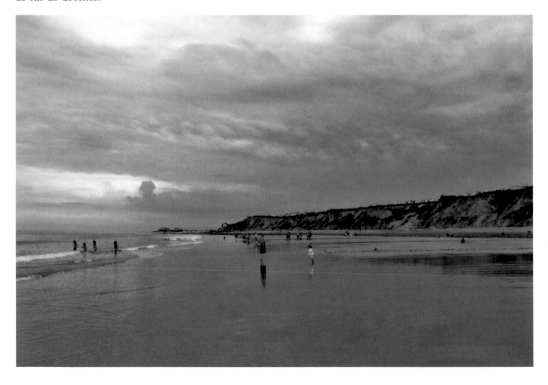

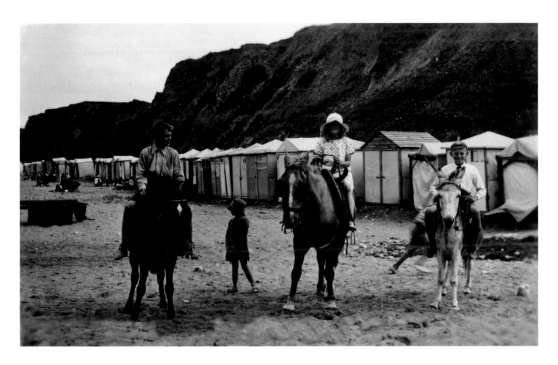

Ready for a Run on the Sands

There are no donkey or pony rides on the sands at East Runton; they have gone, along with the row of beach huts. Caravans can be seen all along the cliff top with great views of the beach and the sea, but no direct access until they get to the gap. It was good to see that traditional pony rides made a return to the beach at Cromer in 2010.

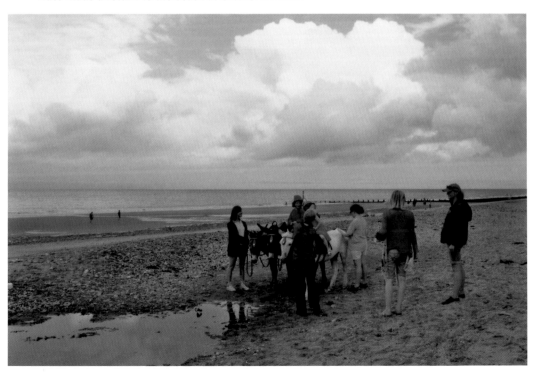

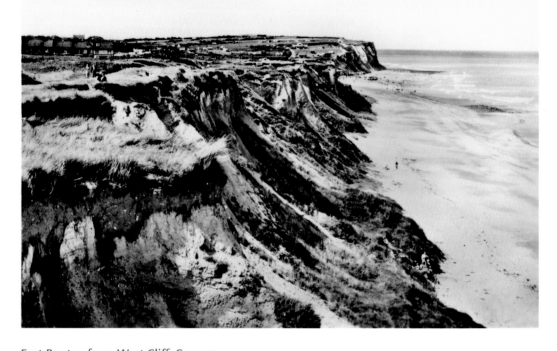

East Runton from West Cliff, Cromer
Travelling along the coast road through the Runtons, you are aware of all the different camp sites.
Along the West Cliff at Cromer there is a walk and a wonderful coastal view that reveals probably
hundreds of caravans nestled in a hollow on the cliff tops. The modern photograph picks out the
small lifeguard hut at the East Runton Gap and gives another view of the beautiful sands.

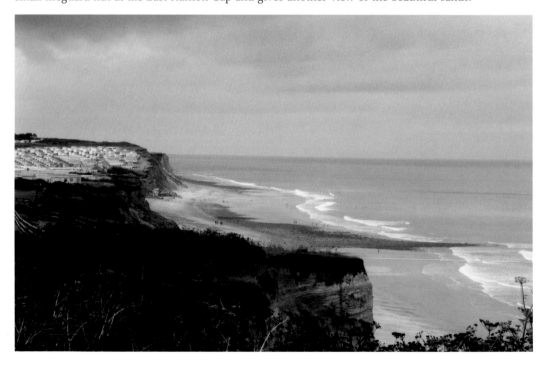

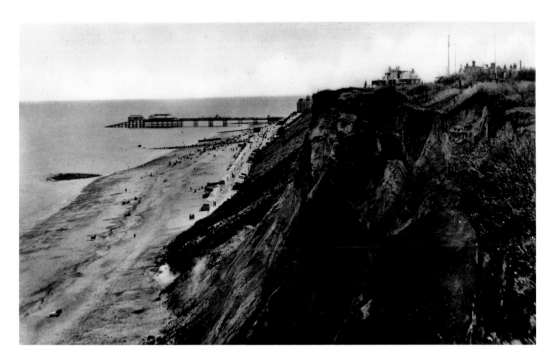

A Cliff Study, Cromer

A dramatic photograph of the West Cliffs at Cromer – similar views can be captured at many points today. The small fishing village of Cromer at the time of the Domesday Book was part of the parish of Shipden, but the sea consumed Shipden and by the nineteenth century the site of Shipden was three quarters of a mile out to sea. Ruins of the church of St Peter formed the old 'Church Rock' until the pleasure steamer *Victoria* destroyed both herself and the Church Rock in 1888.

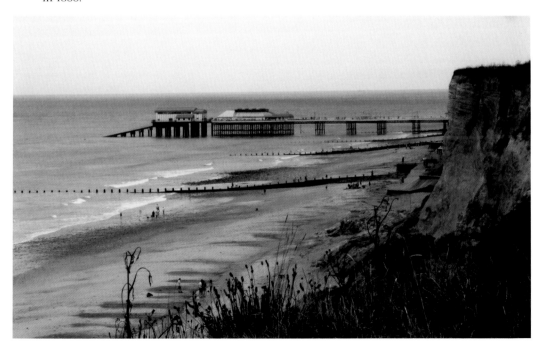

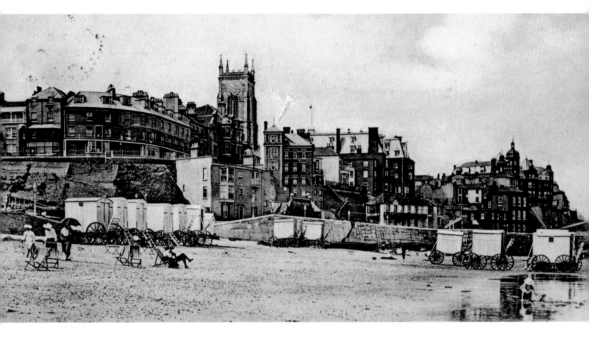

View from the Sands

Cromer was not slow to respond to the ideas of the sea-water cure which had emerged in the middle of the eighteenth century. As early as 1779 Cromer was advertising: 'For the convenience of gentlemen, ladies and others there is now erected at Cromer by Messrs Terry and Pearson a Bathing machine...' Several bathing machines can be seen in this early photograph. Simon's Bath House was built in 1814 but was swept away by the sea some twenty years later.

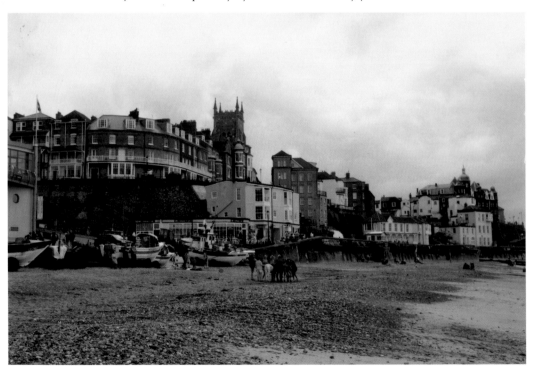

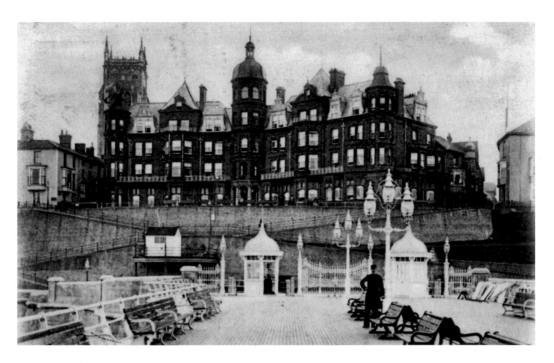

Hotel de Paris from the Pier

For centuries Cromer had battled the sea and was losing. Wooden jetties had been destroyed and a storm had taken the Bath House in 1837 and severely damaged the jetty built in 1822, which was subsequently completely lost in 1843. The Reverend William Sharp launched an appeal for funds and a special rate was levied on some town properties. An Act of Parliament of 1845 led to the building of a new jetty and a promenade or esplanade to protect the seafront properties.

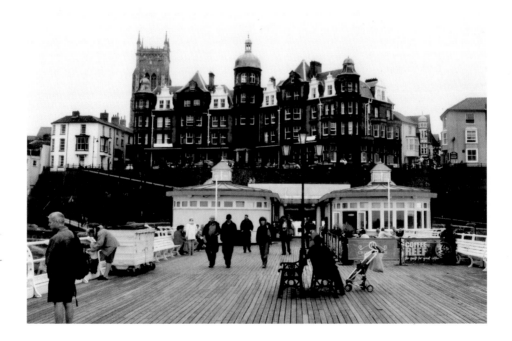

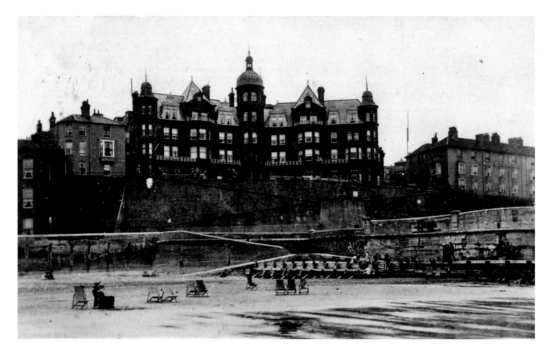

Cromer from the Beach

In 1806 Edmund Bartell Junior remarked on the lobsters, crabs, whitings, codfish and herrings all being caught by the local fishermen. He said the bathing was good, the bathing machines very commodious, but Cromer lacked a good hotel. In 1851, however, the Belle Vue Hotel was built. In 1829 Lord Suffield's summer residence overlooking the jetty was bought by Pierre le François who ran it as the Hotel de Paris. In 1894 it was transformed along with the Belle Vue into the splendid hotel seen in this Edwardian photograph.

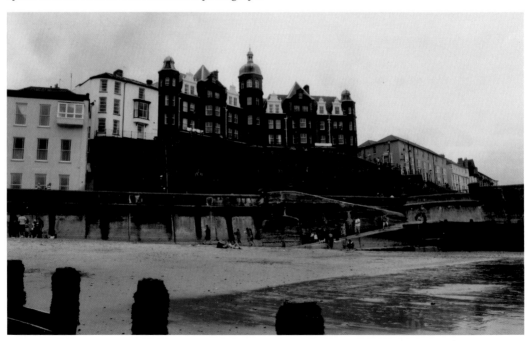

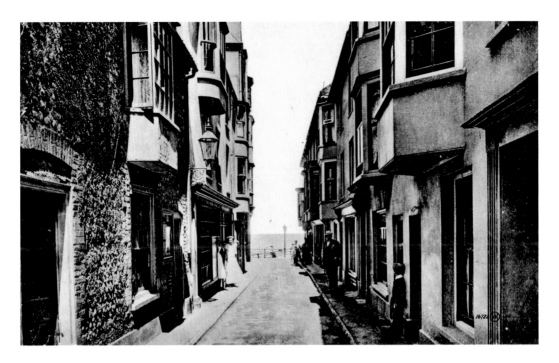

Jetty Street

One of the oldest streets in Cromer. This was the route taken by the ladies to the jetty and the promenade. The bay windows at first-floor level gave visitors a view of the sea but also of the activity in the street below. When the ladies reached the jetty a keeper kept order for their safety and comfort; for example, there was to be no smoking on the jetty before 9 p.m. when the ladies should retire.

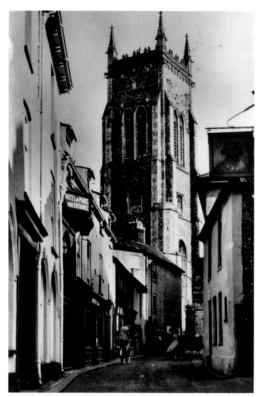
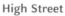

High Street

The old Cromer streets are narrow and unsuited to modern traffic. Towering over them is the church of St Peter and St Paul. The old church at Shipden-Juxta-Mare was called St Peter's and by 1337 was in a poor state with most of its graveyard disappearing into the sea. The site of the present church at Shipden-Juxta-Felbrigg had St Paul's church, also in a poor state. That year of 1337 saw King Edward III give permission for a new church on that site and granted extra land for it.

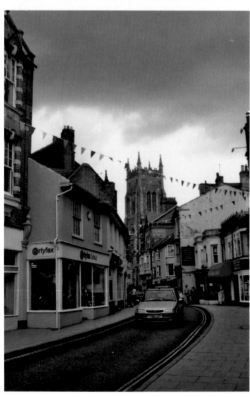

A Bit of Old Cromer

The present church began in the fourteenth century and is subsequently dedicated to St Peter and St Paul. This little bit of Old Cromer is still immediately recognisable. Although most of the other businesses have changed, the Albion Hotel is still the Albion and serving residents and visitors. By Victorian times Cromer was a fashionable place with ladies and their partners to be seen in the narrow streets and promenading down to the jetty.

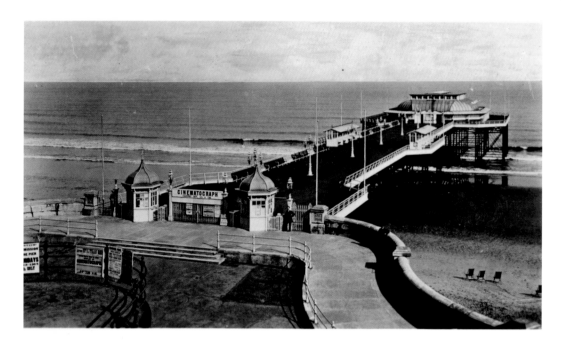

Cromer Pier

In 1806, Edmund Bartell described how ships carrying coal beached at high tide and the coal was carried off at low tide in carts. In 1897 a coal boat, *The Hero*, hit the jetty and damaged it so badly that it was dismantled. In 1901 a splendid new pier, seen here in about 1910, was opened by Lord Claud Hamilton, Chairman of Great Eastern Railway. The Blue Viennese Band played in the bandstand at the end of the pier. In 1905 the bandstand was covered and in 1906 the first concert parties took place in this pavilion.

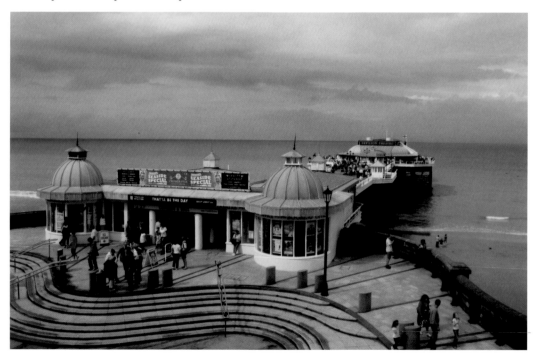

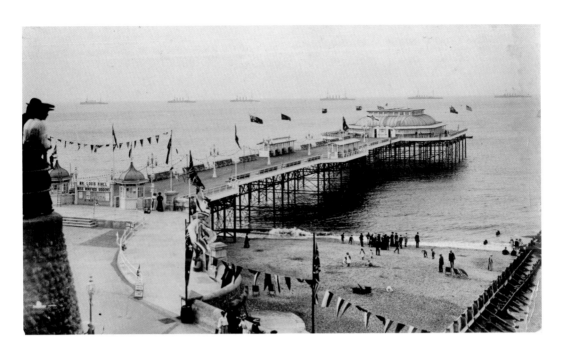

Cromer Pier

Flags are out and a line of ships are on the horizon in this stunning Edwardian photograph. Summer seasons of concert parties continued until the outbreak of the Second World War when the Royal Engineers removed the middle section of the pier. Shows resumed after the war. The pier and pavilion were seriously damaged by the Great Storm of 1953, opening again in 1955. In 1978 the theatre was refurbished and the popular Seaside Specials began. A further redevelopment in 2004 increased the theatre capacity to 510 and added a new bar and restaurant.

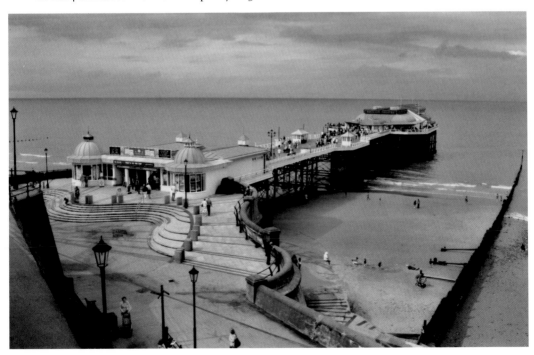

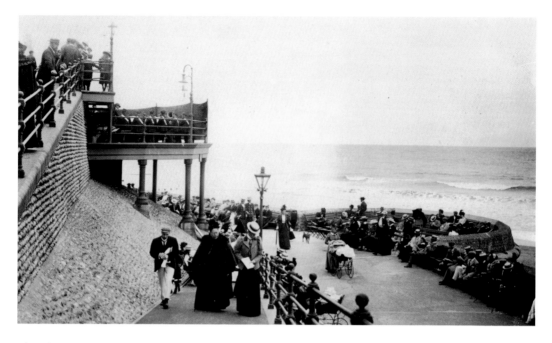

The Zigzag

When the new pier was opened in 1901 the promenade was widened and extended. The splendid zigzag steps take pedestrians from the town down to the east or west promenade or across to the pier. The Edwardian photograph shows a bandstand and a band playing at the halfway point. At some time the area below it has been filled in.

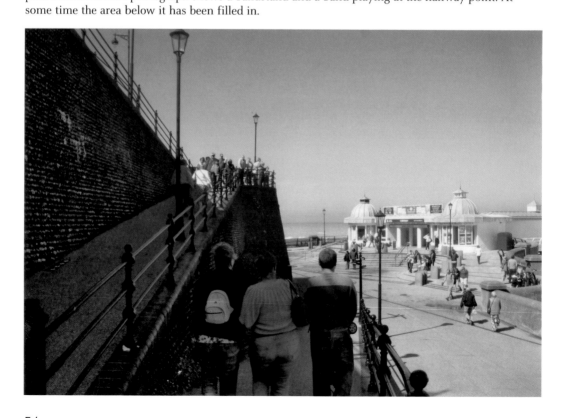

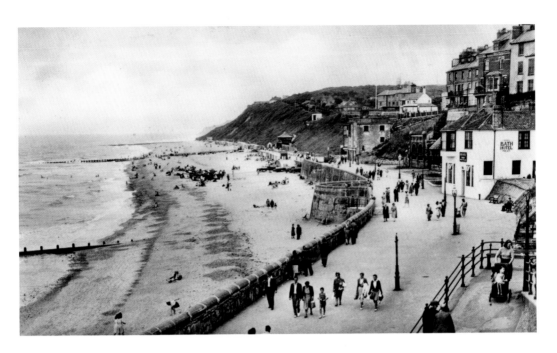

Promenade and Sea Wall

Taken from the zigzag, the Bath Hotel is prominent. In 1875 Lower Tucker's Hotel, partly seen here, was built, probably in anticipation of the arrival of the railway. Cromer station was built by the Great Eastern Railway Co. in 1877 but was outside the town as *Ward's Guide* commented: 'The traveller arriving by rail, on quitting the station, which is on high ground, a long half mile south of the town, at once obtains a good general view of Cromer...'

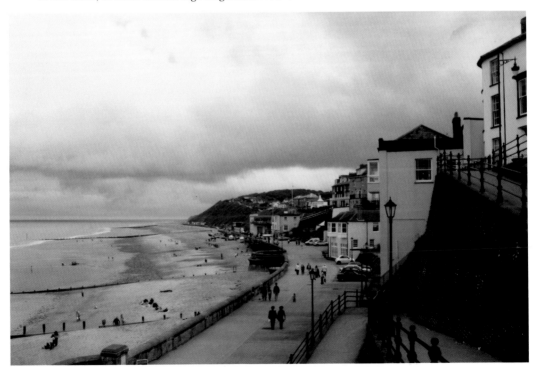

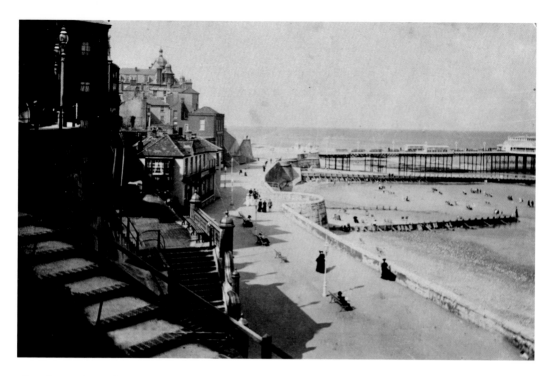

The Pier and Parade
Another magnificent Edwardian photograph capturing some of the various levels of the ways from the town to the promenade. It also shows how the hotels and other buildings rise up from the lower level. The group of buildings on the promenade include the Bath House Hotel and Lower Tuckers Hotel. The old Metropole once towered over them.

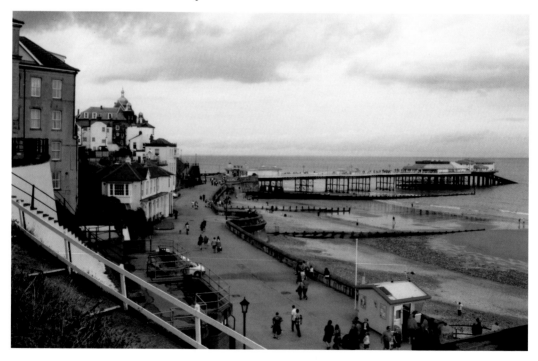

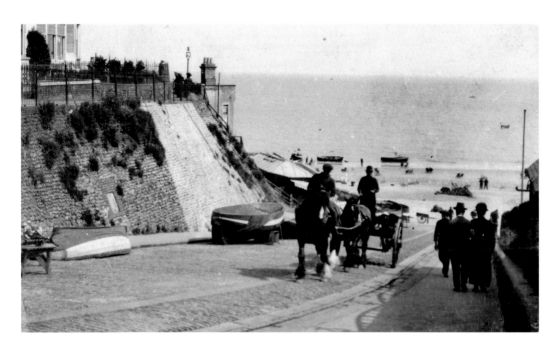

The Gangway

The main access for fishermen and their carts for bringing goods ashore and into the town was at the gangway. Next to the gangway was the lifeboat station. The story of Cromer is a story of the battle with the sea, first to protect the town, then to earn a living from fishing and also to save lives from the sea. The stretch of coast is notoriously dangerous with the Sheringham Shoal and the Haisbro' (Happisburgh) Sands. The Cromer lifeboat station has always been and still is one of the most important on the British coast.

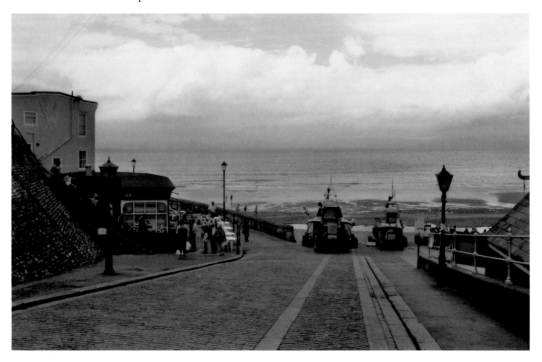

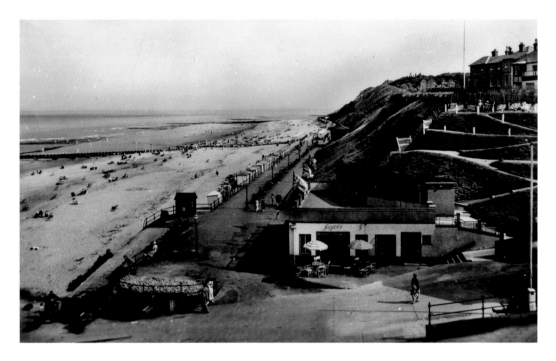

Promenade and Sands, East Cliff

North Norfolk Council invested £6.1 million on enhancing the seafront. This included the renovation of the pier and promenade to link with a new museum to celebrate the 200-year history of the Royal National Lifeboat Institution. The Rocket House Museum and Café has an observation tower near to where Henry Blogg had his bathing-hut and deckchair business. The Doctor's Steps, now a slope, can be seen. They were built in 1796 by Cromer's sole doctor, Sydney Terry, to help his patients benefit from sea bathing.

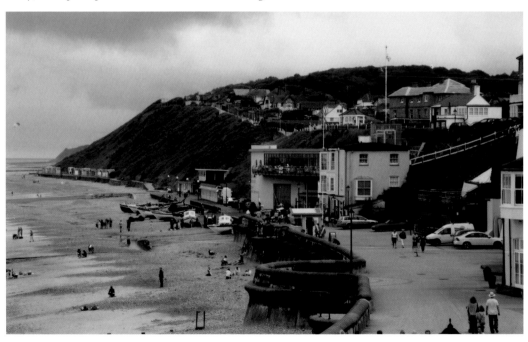

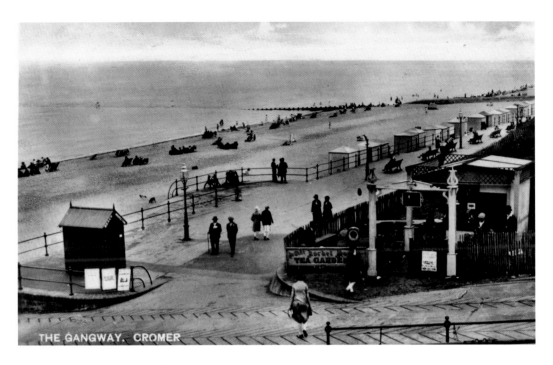

THE GANGWAY. CROMER

The Gangway and Rocket House

The lifeboat was launched from the beach. Henry Blogg, the legendary coxswain for thirty-eight years, and his crew saved nearly 900 lives. He retired in 1947 and died in 1954. He is remembered in a sculpted bust above the old lifeboat station, which describes him as 'One of the bravest men that ever lived'. A new lifeboat station was built at the end of the pier in 1923 and the old station became the Number Two with the Rocket House Café, shown in 1930.

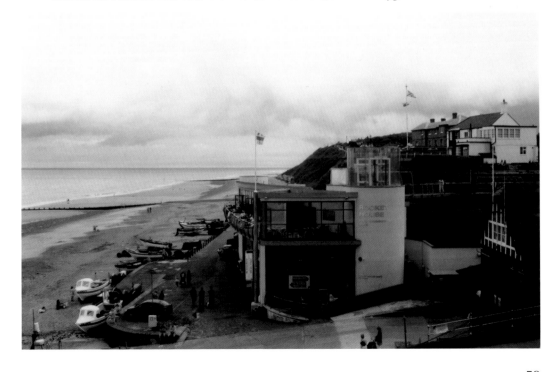

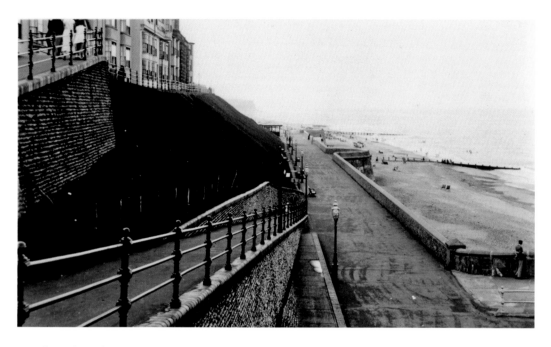

Parade and Sands

At the upper level can be seen the Dolphin, formerly the Regency and built in 1900, and the Westcliffe Hotel. The new parade or promenade was certainly a fine one, not only offering a splendid walk beside the sea, but also protection from the high tides that batter the Norfolk coast. This section has been carefully enhanced.

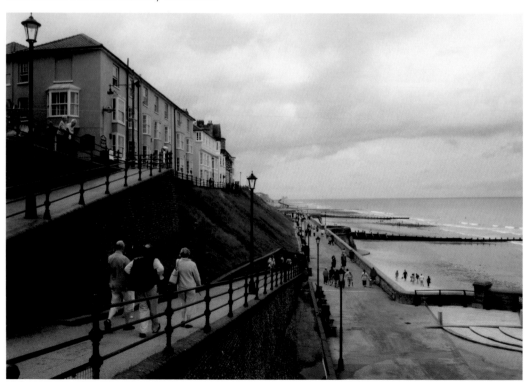

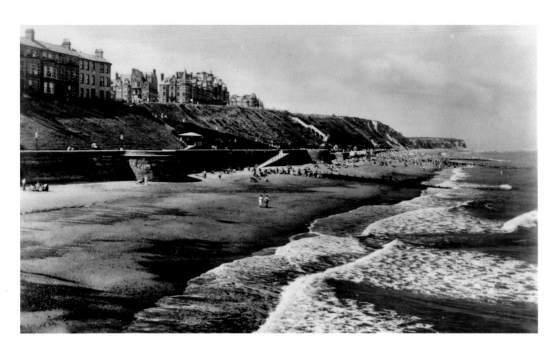

West Beach from the Pier

A good photograph from the pier showing the Melbourne at the far end of the upper range of buildings and distant views of the Grand Hotel and Cliftonville. As part of the enhancements to the esplanade, the architects included some literary quotes inscribed in the stone. Swinburne, the poet, visited Cromer in 1883, staying at the Bath House. He described Cromer as 'rather an Esplanady sort of place'.

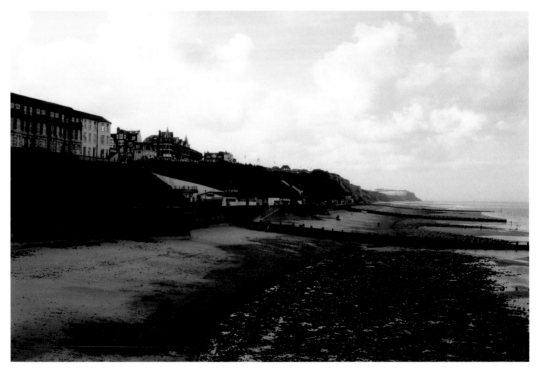

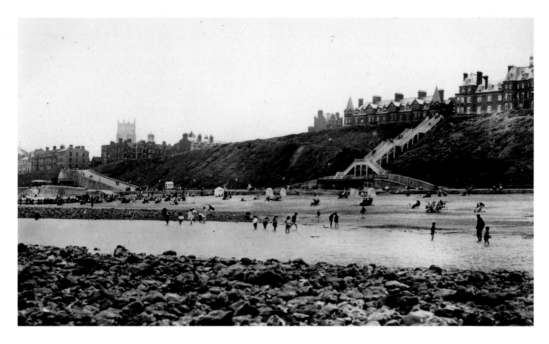

Cromer, the West Beach

Swinburne was following Clement Scott. The Midland & Great Northern had prompted the *Daily Telegraph* to send Scott as the town had not developed as quickly as hoped. Scott's series of articles about the area, written that year, and his book *Poppyland*, published in 1886, did much to popularise Cromer and the coast to Overstrand.

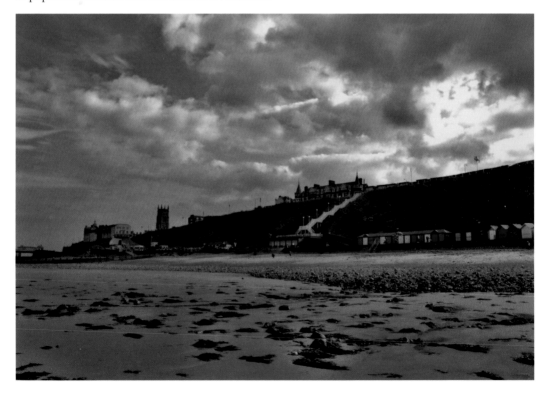

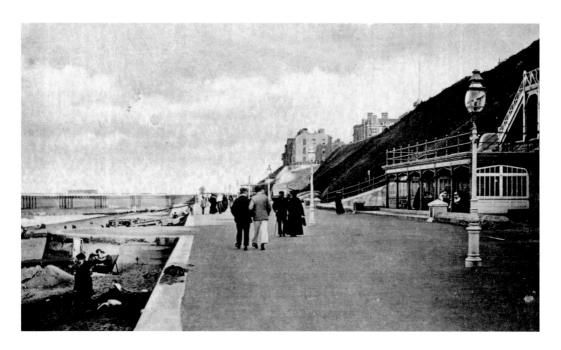

West Esplanade

Cromer had a reputation for gentility. The Empress of Austria stayed at Lower Tucker's Hotel in 1887. She was remembered for promenading outside the hotel, not wearing a hat, but carrying a red parasol. Everyone would bow as she passed. In 1887 Sir Herbert and Lady Beerbohm Tree, their daughter Viola and her nanny stayed there after the Empress. Clement Scott observed the holidaymakers, digging on the sands, playing lawn tennis, working, reading, flirting and donkey riding.

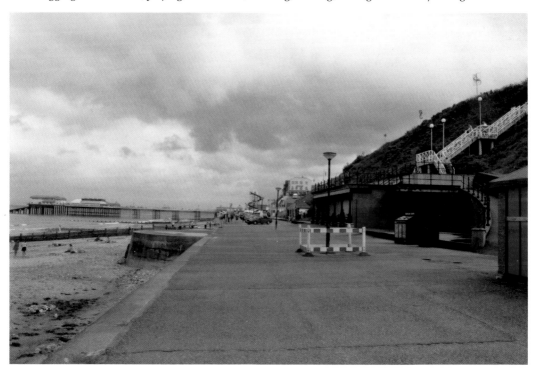

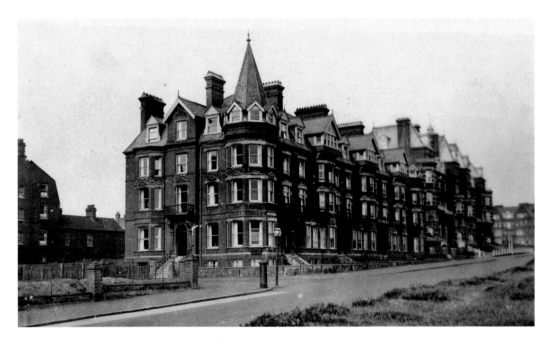

Runton Road and the Corner of Cabbell Road

As the building boom began to take off, Benjamin Bond Cabbell died relatively young in 1892. More land was put up for auction and a building boom occurred. Suncourt Holiday flats now occupy the corner building, while next along Runton Road is the Anglia Court Hotel, up for sale in 2010. Beyond them is the Grand Hotel.

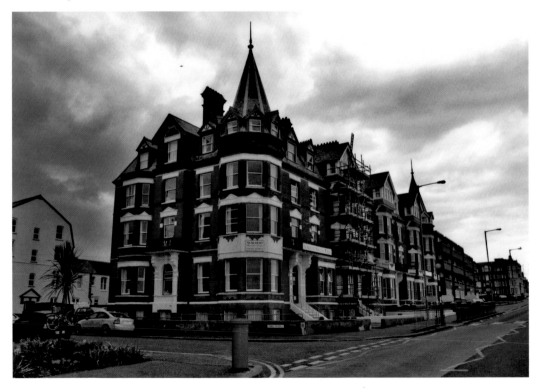

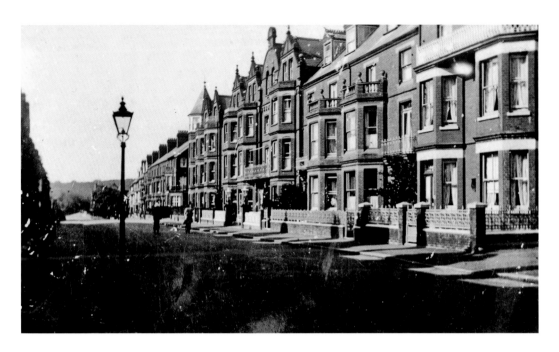

Cabbell Road

Benjamin Bond Cabbell's name lives on in Cabbell Road, a magnificent Victorian street that helped link the Beach Station with the seafront. The Elmhurst Hotel can be seen in the middle. It was the arrival of the Eastern & Midlands Railway at the new Beach Station in 1887 that really got Cromer moving. Benjamin Bond Cabbell at Cromer Hall had large estates ready for development along the West Cliff. His family encouraged the coming of the railway and owned the local brickworks.

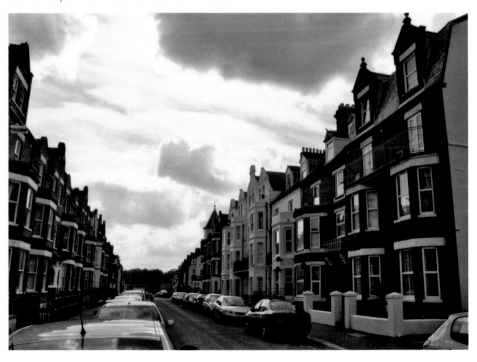

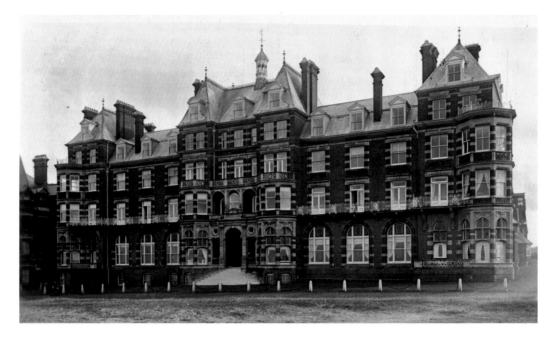

Grand Hotel

In 1890-91 George John Skipper, who had just designed Cromer's new Town Hall, was responsible for designing the Grand Hotel for local businessmen on land put up for auction by Bond Cabbell. In 1893-94 the Skipper also designed the Metropole Hotel in Tucker Street for another syndicate. In 1969 a new owner renamed the Grand the Albany hotel, but it burnt down that same year and was replaced by Albany Court.

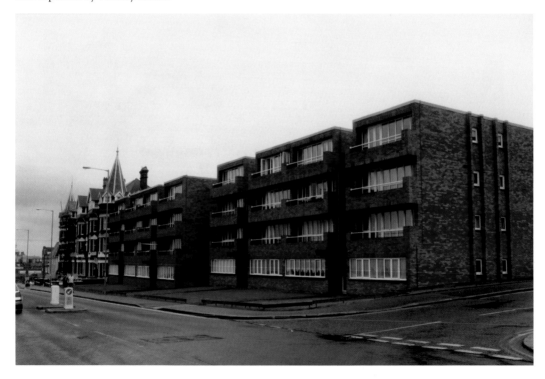

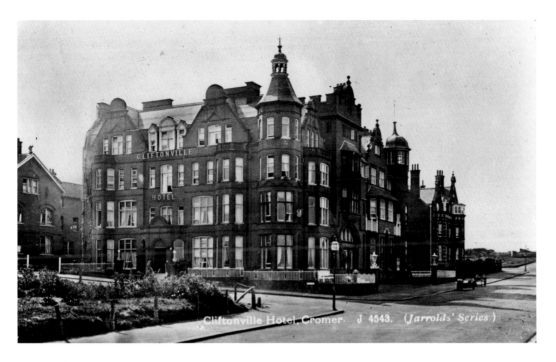

Cliftonville Hotel, Cromer. J 4543. (*Jarrolds' Series*)

Cliftonville Hotel

In 1894 the Jarvis family, with George Skipper, were redeveloping the Hotel de Paris as a rival for the Grand and the Metropole. The splendid Cliftonville Hotel was built on the Runton Road along from the Grand. It was not one of Skipper's hotels, but has survived and is still in business today, unlike the Grand and the Metropole (which was demolished in the 1970s).

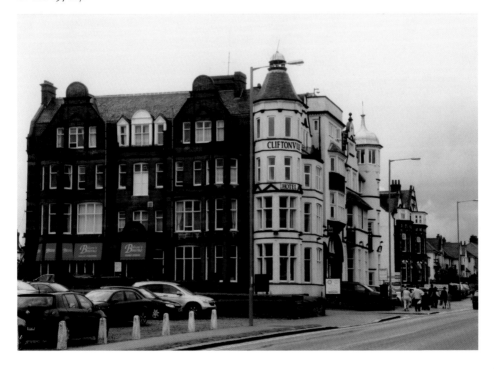

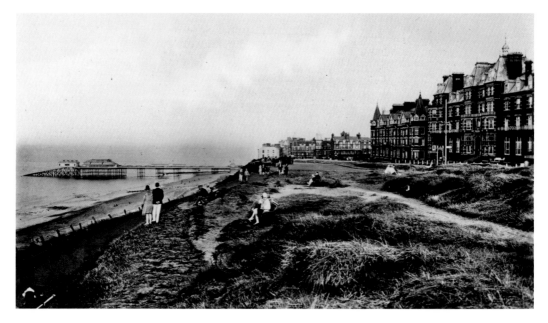

West Cliff

Early photographs of the Grand and other Victorian hotels along the Runton Road show the area in front of them, known as the Marrams, looking quite rough and not formally laid out. This photograph, which appears to be from the late 1920s – as the lifeboat station can be seen on the end of the pier – shows the clifftop promenade. Today there is a bowls club, a large putting green and colourful sunken gardens.

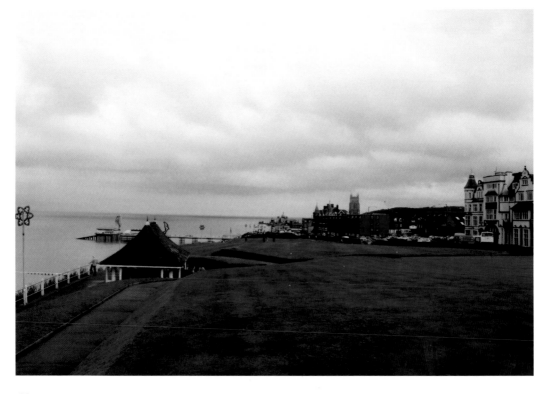

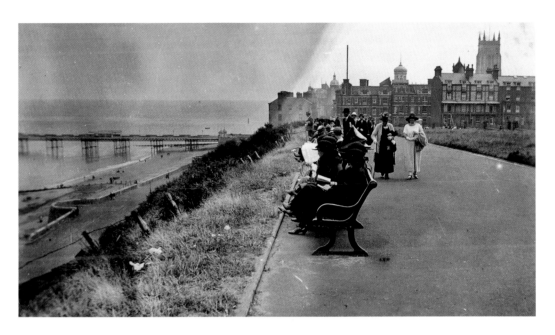

Edwardian West Cliff

Before the rapid growth of the 1890s, the reputation of Cromer as a 'select resort' was largely due to the influence of some prominent interrelated families: the Gurneys, the Buxtons, the Hoares, the Barclays and the Birkbecks. All were wealthy, acquiring some of the finest houses like the Grove and Cliff House, but they were also religious and benevolent, being concerned for the welfare of the poor. They had large families and enjoyed entertaining. They set the tone for Victorian Cromer.

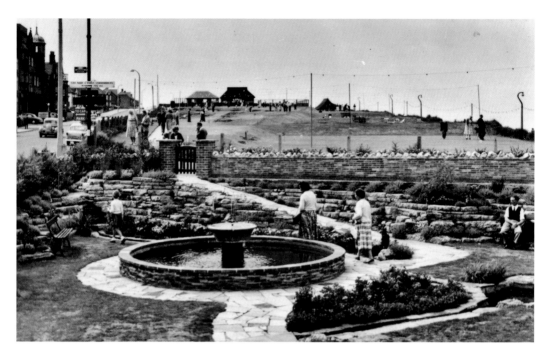

West Cliff Sunken Gardens

Sunken gardens are a popular feature of many seaside resorts. The north Norfolk coast can be a very windy place and sunken gardens like the ones at Cromer provide shelter for both plants and people. They form a good sun trap, usually quiet and away from the more boisterous sands.

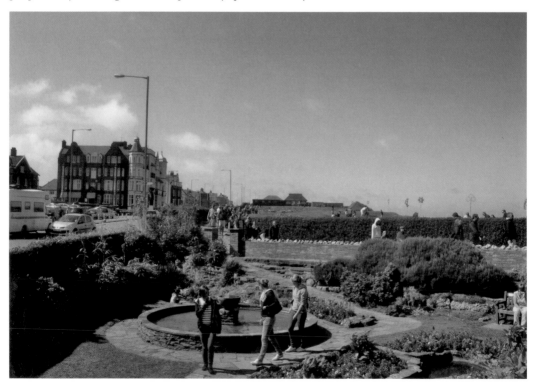

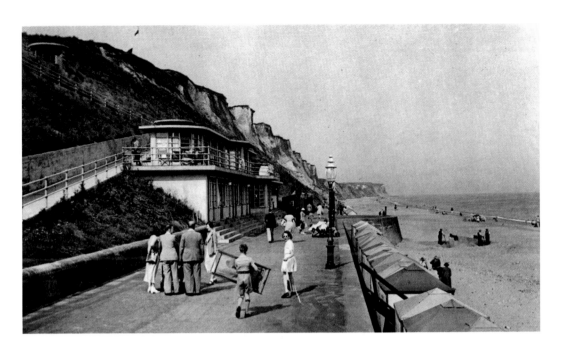

Promenade and Tea Rooms

A sloping walkway zigzags down the cliff to the promenade where there is a charming 1930s pavilion building that houses tearooms, shop and individual sun lounges above. The beach huts and tents have now moved up onto the promenade. Clement Scott in 1883 described how visitors promenaded: 'It was the rule to go the sands in the morning, to walk on one cliff for a mile in the afternoon, to take another mile in the opposite direction at sunset, and to crowd on the little pier at night.'

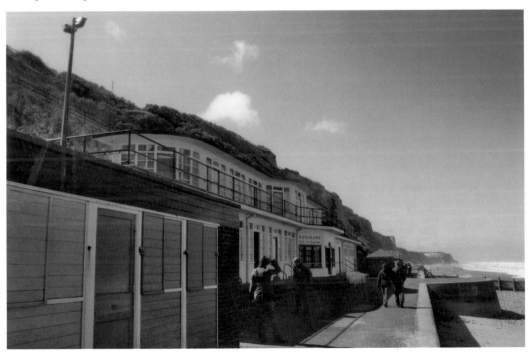

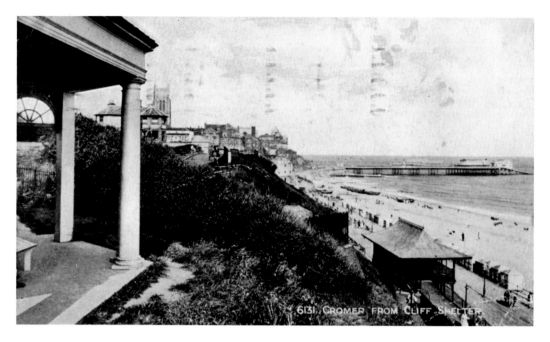

Cromer from Cliff Shelter

A distinctive pagoda-style shelter was given by Benjamin Thomas Rust in 1927 in memory of his father, Henry Rust (1840-1923). Because of the erosion of the cliff it has been rebuilt further back, but it still gives classic views of Cromer and the sands. North Lodge Park and the putting green are behind it. This path towards the lighthouse, just like earlier days, is a popular walk made more attractive by the lights, seats and rails.

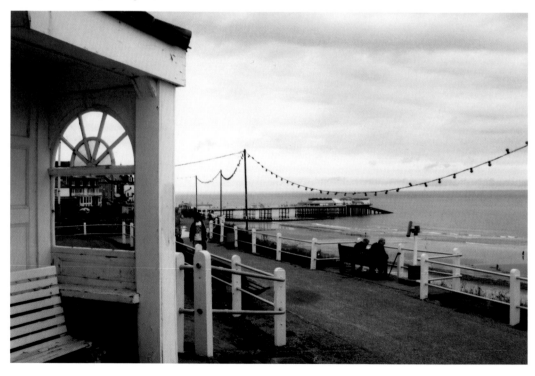

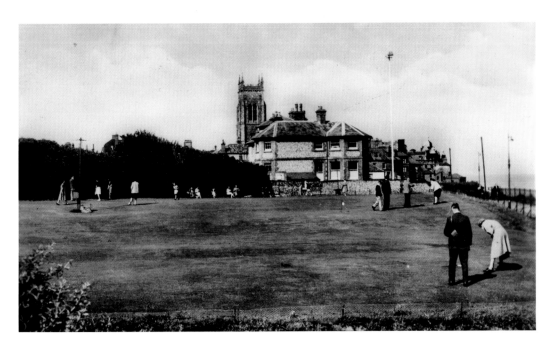

North Lodge Park

Once owned by the Goldsmith's Company, then the Hoare family, North Lodge, North Cottage and the Park were sold to Cromer Urban District Council in 1928. North Lodge became the council offices and other attractions for the public included two hard tennis courts, a bowling green, model village, model yacht pond and large putting green. The putting green is still in use today along with the bowling green, the model yacht pond and a children's corner.

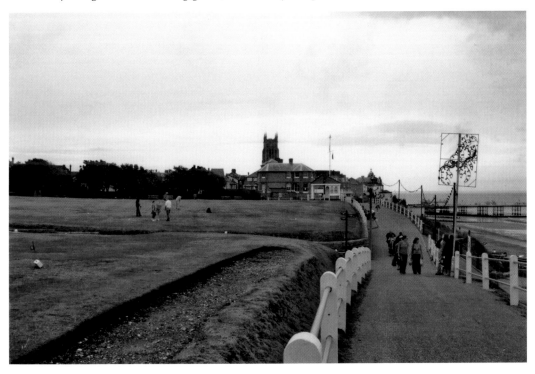

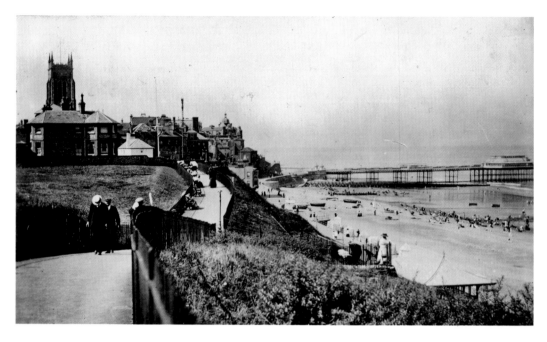

Cromer East

Properties on Cliff Drive overlook the path that leads up to Warren Woods and Happy Valley. As the path climbs higher there are some wonderful views of Cromer, the pier and the beach below the cliffs.

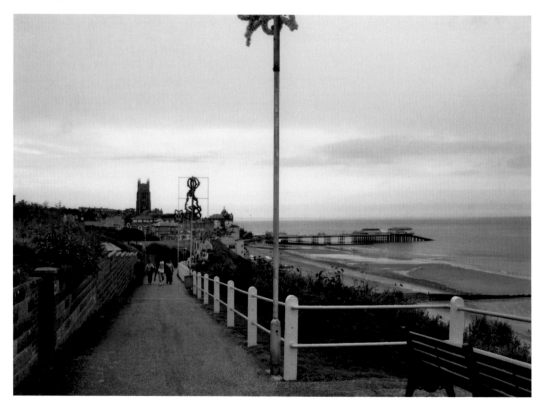

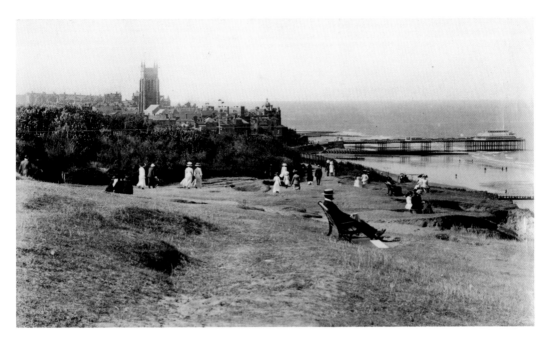

East Cliff

A delightful Edwardian photograph. You walked, sat a while enjoying the view and the sea air, then walked some more, perhaps stopping to talk to those you knew or, as Clement Scott wrote, 'flirting'.

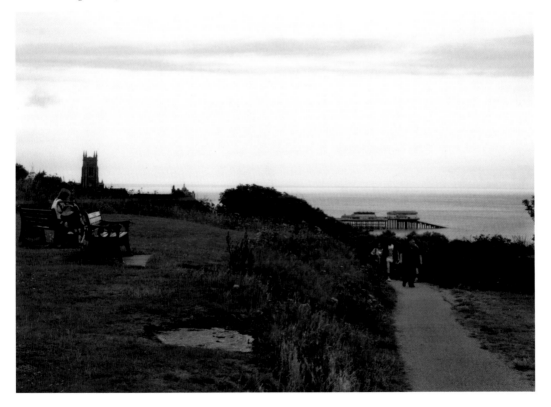

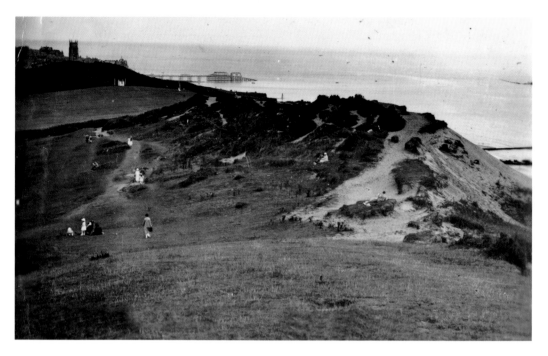

Happy Valley

Happy Valley dips and rises, with sandy hills to climb and gorsy hollows. All the while, not far away, but a long way down, are views of the beach and the sea. This card was posted to London at the end of July 1930: 'Should like to stay here till the end of the season as we are enjoying it so much, but are already "on the rocks", so must return Saturday.' Not a lot changes there then for most holidaymakers.

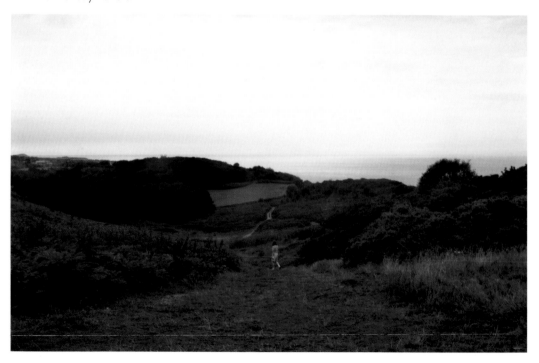

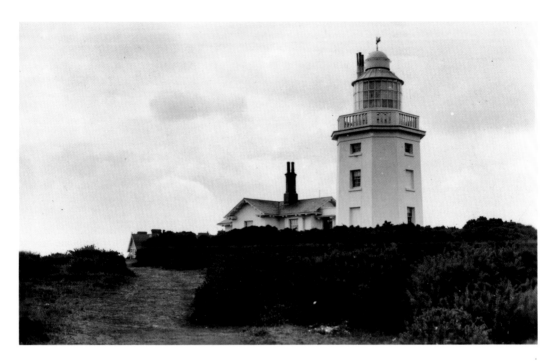

Cromer Lighthouse

Clement Scott wrote that 'No one thought of going beyond the lighthouse; that was the boundary of all investigation. Outside that mark the country, the farms and villages were as lonely as the Highlands.' The lighthouse stands 274 feet above high water and was built in 1883 to replace the first lighthouse at Foulness, which had been built in 1719 but succumbed to the erosion of the cliff and fell into the sea. This lighthouse became electric in 1958 and since 1990 has been fully automatic, monitored from Harwich.

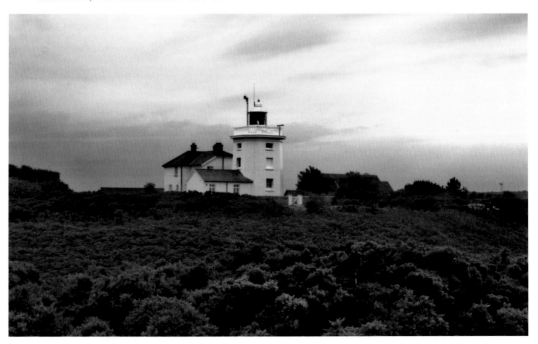

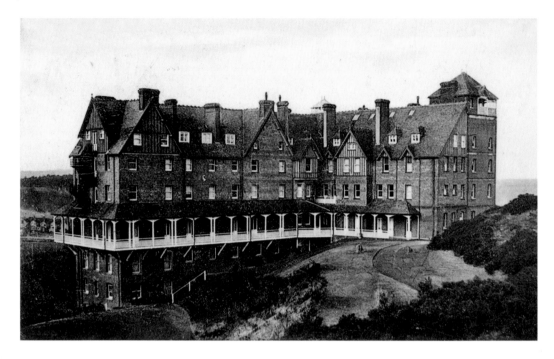

Royal Links Hotel

The golf course was created in 1887 and the Prince of Wales was a patron. The magnificent Royal Links Hotel stood on the course just to the south-west of the lighthouse. Sir Arthur Conan Doyle stayed at the Royal Links in 1901 and, when dining at Cromer Hall with Benjamin Bond Cabbell, heard the story of Richard Cabbell who had murdered his wife and then had his throat torn out by her faithful hound. This was the inspiration for *The Hound of the Baskervilles*. The Royal Links Hotel was destroyed by fire in 1949.

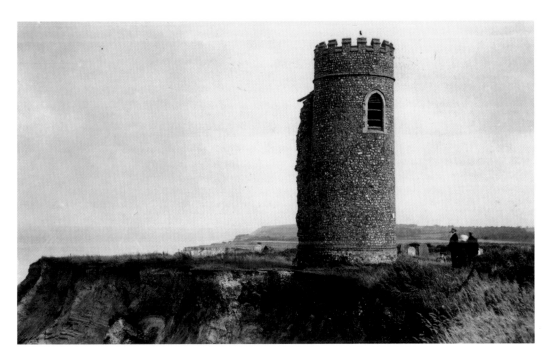

The Garden of Sleep, Sidestrand

Clement Scott came across the ruined church at Sidestrand which was slipping over the cliff. The church had been rebuilt further inland in 1881 using the flint from the original, leaving the tower and the graveyard to its fate. Scott wrote the sentimental poem 'The Garden of Sleep' which began, 'On the grass of the cliff, at the edge of the steep, / God planted a garden – a garden of sleep!' It became a popular song. Today St Michael, Sidestrand, stands beside the coast road.

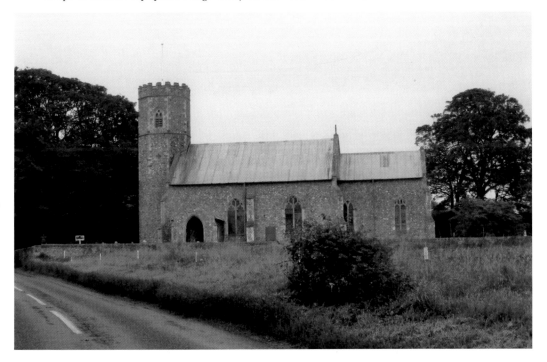

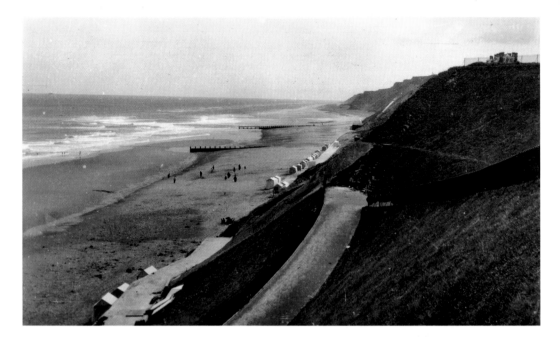

The Beach, Overstrand

The Lord of the Manor of Overstrand was Lord Suffield, who had the summer residence at Cromer overlooking the jetty. He lived at Gunton Hall and had an estate of some 15,000 acres. In 1826 he attempted to have a harbour built at Overstrand to improve transport to the area, but it came to nothing. His son, the 5th Lord, had more success as he was one of those responsible for bringing the Great Eastern Railway to Cromer. It was Lord Suffield who developed Cromer Golf Course on his unproductive clifftop acres.

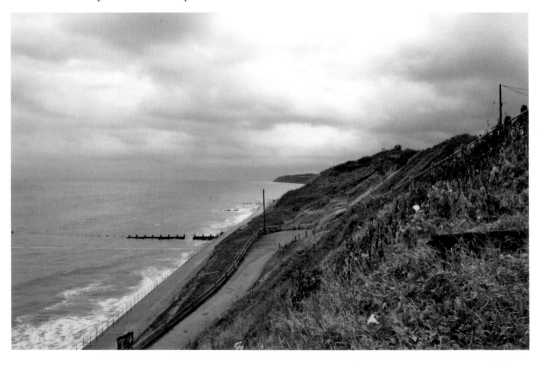

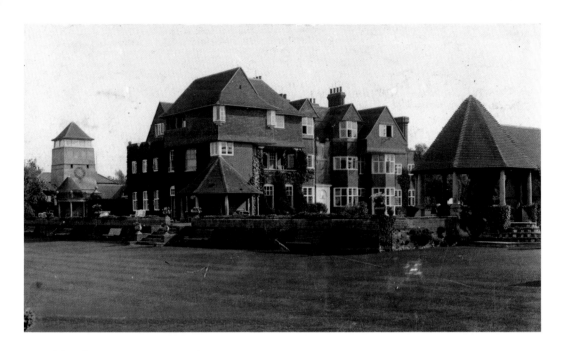

The Pleasaunce, Overstrand

Overstrand, with its beautiful beaches, became the choice of many of the rich and famous. As Clement Scott was a drama and literature critic, many visitors came from those circles including Ellen Terry, Sir Henry Irving, the Beerbohm Tree family and Walter Swinburne. When Lord Suffield put the Overstrand estate up for auction in 1888 with a view to developing an estate of terrace houses and villas, Cyril Flower MP, later Lord Battersea and Overstrand, bought two cottages and thirty acres and with architect Edwin Lutyens created The Pleasaunce.

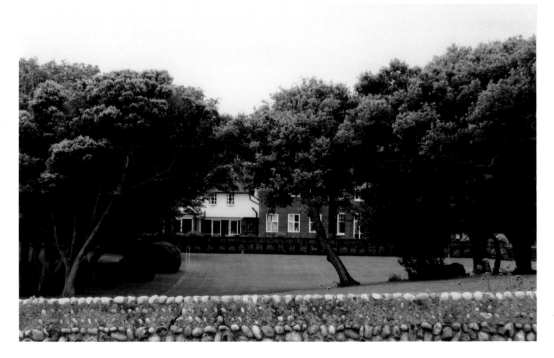

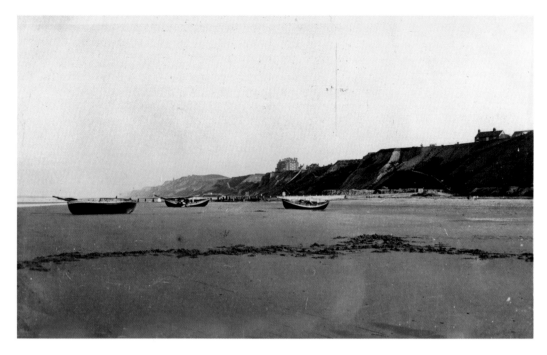

The Cliffs, Overstrand

Lord Morley, Lord and Lady Hillingdon, Sir George and Lady Lewis (with the Danish Pavilion), Lord Wolverhampton and Sir Frederick MacMillan all built summer residences. Sir Edgar and Lady Speyer had Sea Marge built in 1908 and it has been beautifully restored as a fine hotel. The Churchill family were frequent visitors to both Sea Marge and Overstrand. Clementine Churchill stayed at Pear Tree Cottage in 1914 and Winston Churchill spent several Sundays there in the weeks before the outbreak of the First World War.

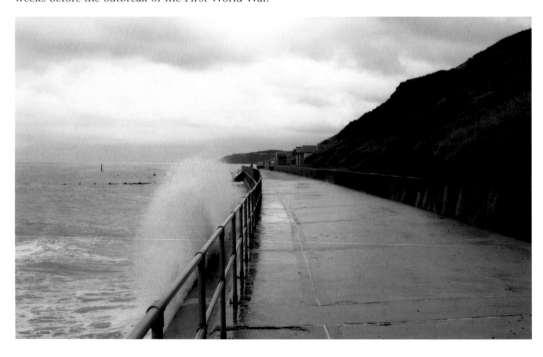

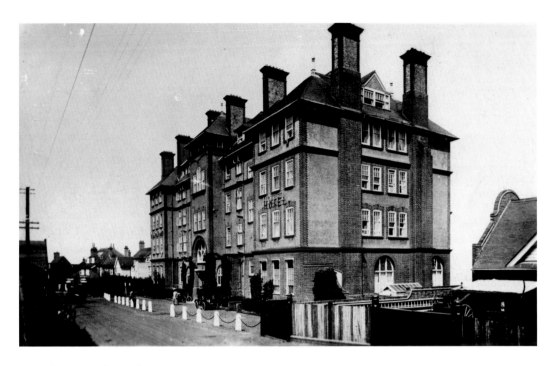

Overstrand Hotel
The rich and the famous couldn't stop the sea battering away at the eastern end of Overstrand. The huge Overstrand Hotel, built on the High Street in 1903 and seen on so many photographs, suffered a serious fire just after the Second World War and was subsequently lost to the erosion of the Cliffs, as was that end of the High Street. The foundations of the hotel can be seen on the edge of the cliff fall. Massive sea defences now protect the coast.

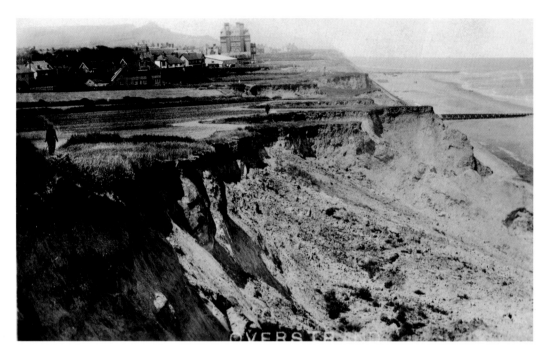

Overstrand

A fine photograph probably dating from about 1920, near Sidestrand. The erosion of the cliffs is startling in the foreground while in the distance the Overstrand Hotel looks to be safely inland, but it wasn't. Overstrand remained quite a small village. Effectively, Lord Battersea, by buying up the plots, stopped the development of rows of villas and kept the village 'select'. That and the cliff falls deterred investment.

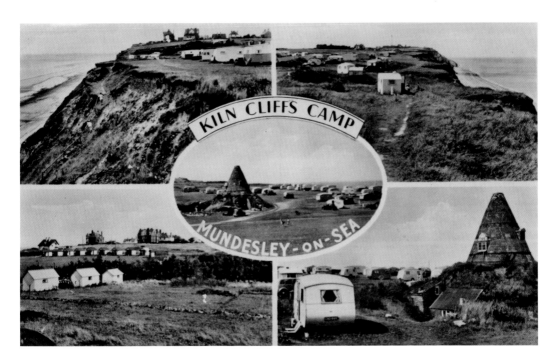

Kiln Cliffs Camp, Mundesley

If Overstrand was the village of millionaires there were still going to be plenty of places for those whose idea of bliss was getting away from it all in a caravan. The Norfolk coast has hundreds of caravan sites big and small. They offer independence, a chance to enjoy wonderful scenery and a good holiday at a price that can be afforded. For many, a caravan at the seaside was, and still is, their first holiday experience. For others, caravanning is a way of life.

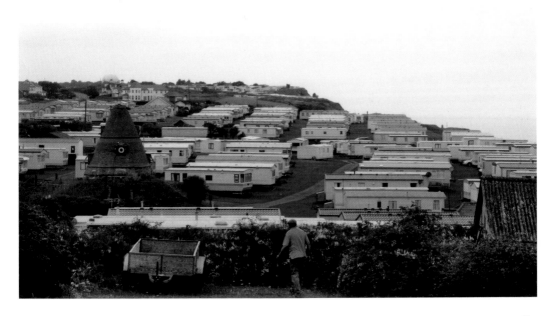

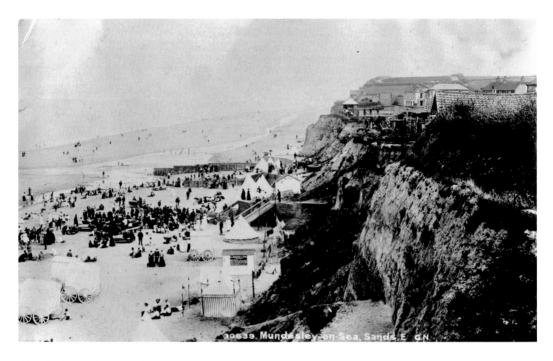

Mundesley-on-Sea, 1908

A crowded beach scene. Bathing machines, bell tents, some form of entertainment, steps down from steep cliffs and an odd collection of buildings on the cliff top. This is Mundesley, perhaps the next major seaside resort on the Norfolk coast. On 1 July 1898 passengers were able to travel on a new railway line from North Walsham to Mundesley to what was described as a 'little fishing village and coastguard station'. Apart from the Royal Inn and the Ship, there were 'a few small lodgings'.

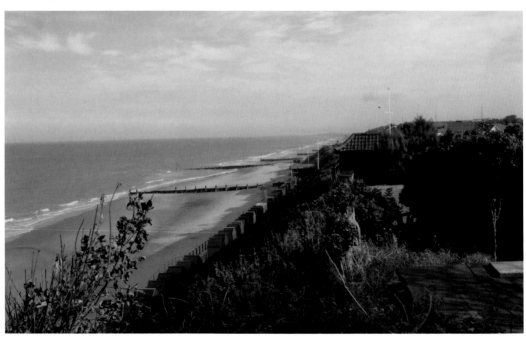

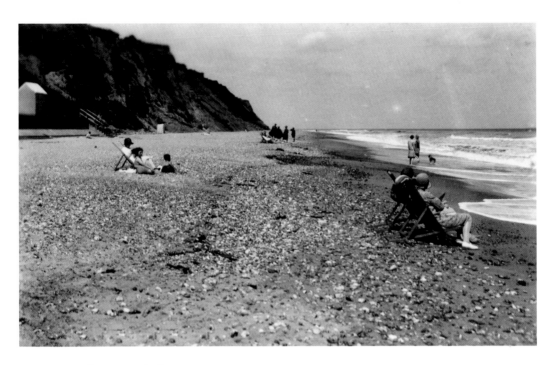

The Cliffs at Mundesley-on-Sea

There had been several attempts to promote Mundesley as a new seaside resort. As early as 1823 the *Norwich Mercury* was reporting that 'the spring discovered at Mundesley, possessing great chalybeate qualities, has already excited curiosity. We understand that it is more strongly impregnated with iron sulphate and sulphate of magnesia than any other of a similar nature in the kingdom ... It is in contemplation to erect a bath-house and Pump-room on the spot, the supply of water being very abundant.'

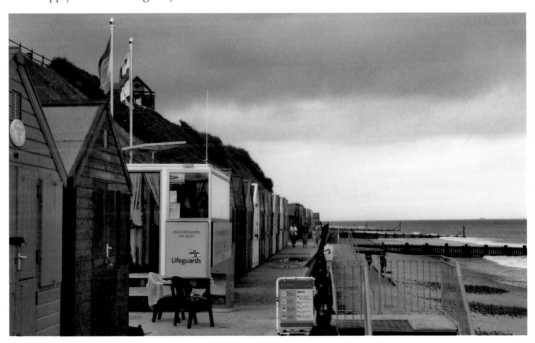

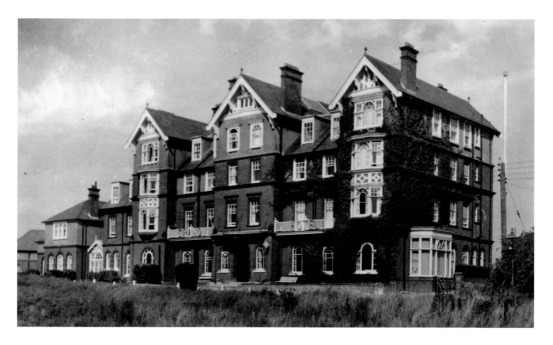

The Grand Hotel

In anticipation of the railway coming, three large hotels were opened to join the Royal, formerly the New Inn and claiming associations with Lord Nelson. There was the vast Grand Hotel on the brow of a hill beside the Cromer Road. In 1959 the hotel was renamed the Hotel Continental. It had its own zigzag path, which is still there, down to the beach. For the last several years it has been apartments and what was once a magnificent building is now in a poor state of repair.

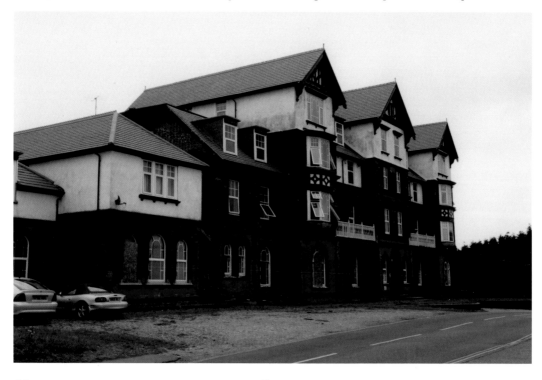

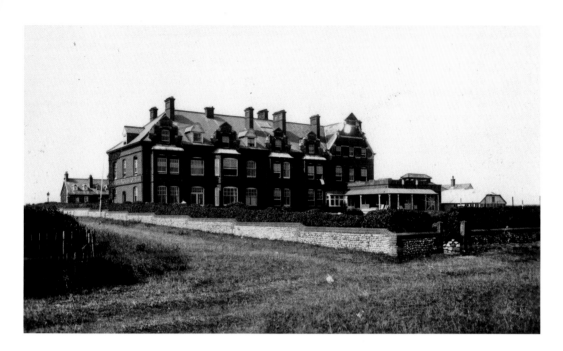

The Clarence

The Clarence, on the Cromer side of Mundesley, with spacious grounds on the cliff top with its own steps to the beach, was in business in the 1890s. When the railway opened, fifty guests dined at the Clarence. In replying to the toast of 'Success to Mundesley', John Gaymer said, 'For centuries the finest air in the kingdom has been wasted, because nobody had the courage to bring the people to our district.' The Clarence closed in 1938 and is now a residential care home.

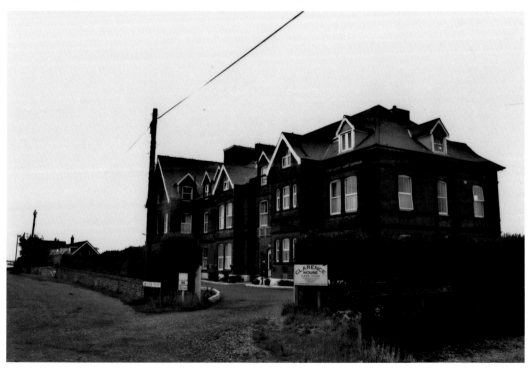

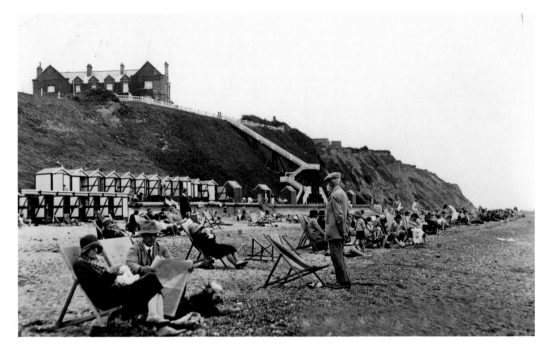

The Manor Hotel

Overlooking the centre of Mundesley, the Manor Hotel was opened in 1900. The photograph dated 1930 shows the splendid steps that led from the hotel down to the beach. Sadly they have now gone, but the hotel has been splendidly refurbished and is still in business. Mundesley beach was heavily mined during the Second World War and only cleared in 1953. In the gardens at the cliff top is a monument to the twenty-six Royal Engineers who lost their lives clearing mines along the Norfolk coast.

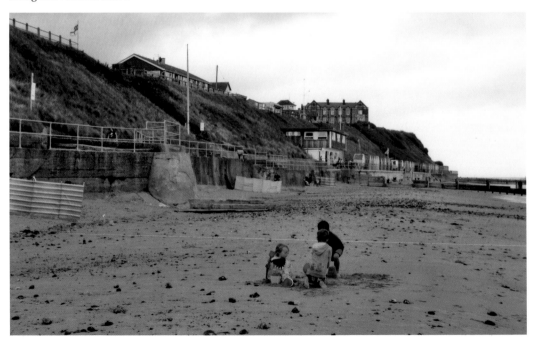

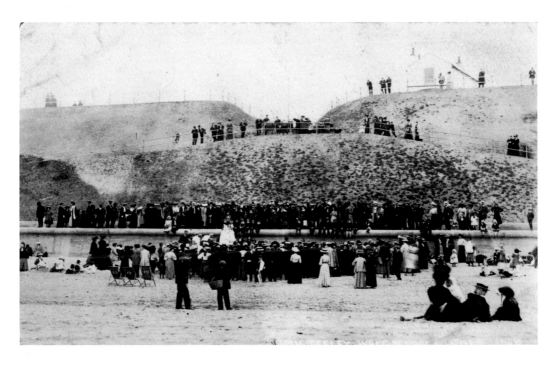

The Central Beach

This is Whit Monday 1908 and a large crowd is gathered watching a Pierrot concert party. For a while the railway brought huge Bank Holiday crowds to the resort. The railway fell victim to the Beeching cuts of 1964 and the grand station was demolished. Mundesley remains popular today as one of the quieter resorts. The beach is superb and lifeguards keep watch on the paddling and bathing area. There is a beach café at the foot of the slope down to the promenade.

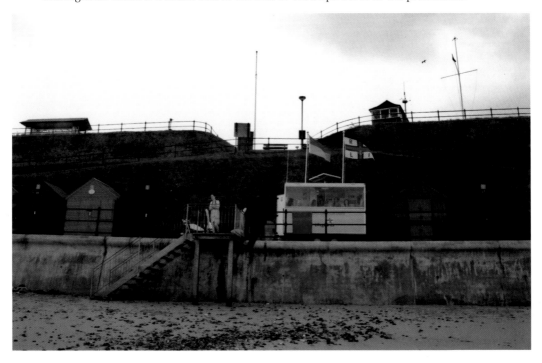

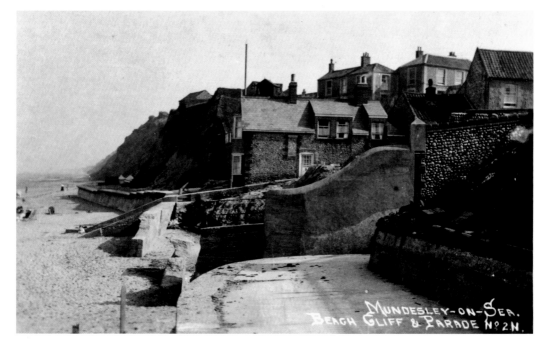

Beach Cliff and Parade

Mundesley was a small fishing village before plans were made to develop it as a seaside resort. This is the Fishermen's Gangway with a heavy steel gate that can be pulled across the slipway. William Cowper (1731-1800), the poet, spent time in Mundesley in 1795 and 1796. A melancholic man who suffered from depression, his work often featured storms and shipwrecks as images of the mysterious ways of God. Perhaps one of his last poems 'The Castaway' was inspired by walks on Mundesley sands?

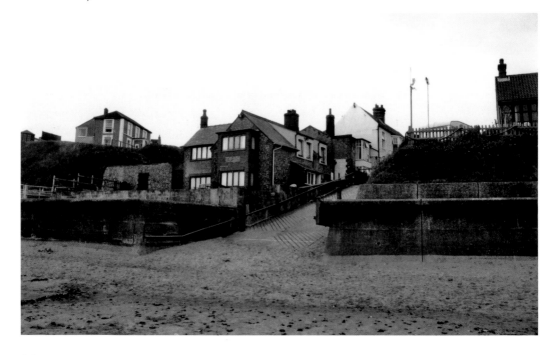

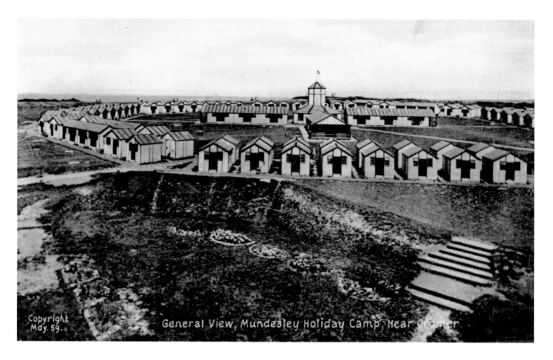

General View, Mundesley Holiday Camp, Near Cromer.

Copyright
Mdy. 59.

Mundesley Holiday Camp 1934

Situated on the cliff top near Paston Mill, Mundesley Holiday Camp opened in 1934, from which time these two photographs date. It was purpose-built and offered full catering. The huts or chalets form a circle round the water tower, wash and toilet block, with the pavilion close by. The sunken garden in the foreground was a popular feature and the beach and the sea were very close by. Today the camp has all modern facilities and entertainment and caters for some 230 adults only.

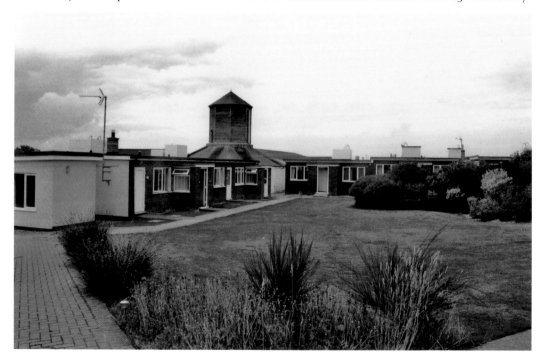

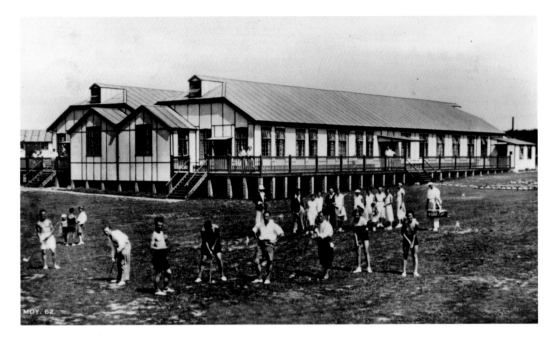

The Pavilion, Mundesely Holiday Camp 1934

Some of the first holidaymakers pose with golf clubs. The message sent home from two youngsters to their Ma and Pa refers to 'very strong cold winds. Glad to have long trousers and sleeved sweater ... the camp and management in short is excellent ... no hope of bathing this holiday I'm afraid, almost ice floating about...' And that was June! Since the camp opened there has been some coastal erosion and, strangely, behind the modern chalets the old huts gaping open can still be seen from the cliffs.

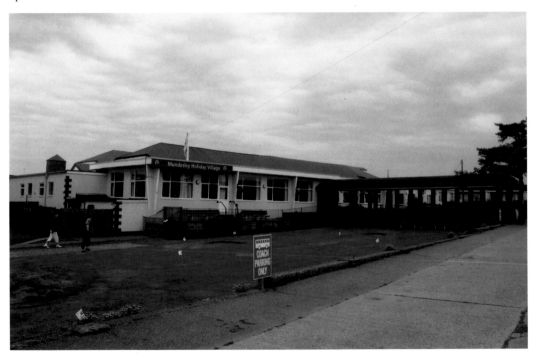

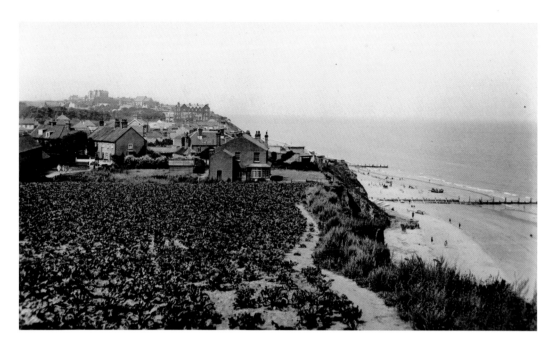

East Cliff, Mundesley

The view back to Mundesely from the cliffs near the Holiday Village. Despite the optimism of the railway arriving in 1898, that same year a tremendous cliff fall on the Overstrand side of Cromer put a blight on the sale of plots on the Cliftonville Estate. As the local paper warned: 'Speculators at Mundesley must take care they do not build upon land too near the sea otherwise they may wake up one morning to find their investment has slipped through their fingers.' And that is still true today.

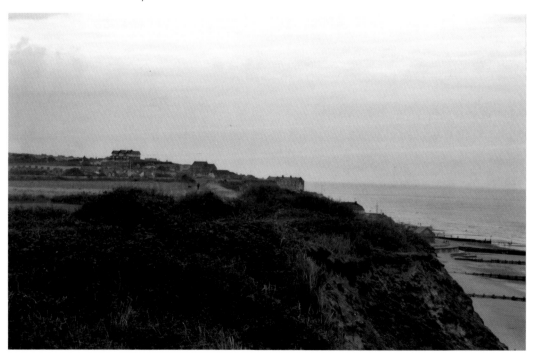

Acknowledgements

In 1982 I wrote *Coastal Resorts of East Anglia, the Early Days* for Terence Dalton. I have relied on the original research I did for that for much information. I have also enjoyed *The North Norfolk Coast* by Neil Storey (Sutton 2001) and *The Lost Coast of Norfolk* by Neil Storey (Sutton 2006, The History Press 2009).

All the old photographs are in my own collection.

My thanks to all those who have helped in any way, including Cromer Museum, who have published an excellent series of Brief History Guides; Tourist Information Centres; Mhain Campbell; and numerous car park attendants.

There is something about the Norfolk coast and trampling along beaches, climbing up and down cliffs or walking along cliff tops that brings a smile and a greeting from complete strangers. That, and the chance to photograph some of the most beautiful places, makes it all a pleasure.

Three of my children, Lauren, Lee and Cassie, have often accompanied me and sometimes appear in photographs. Lee more than most as he is my 'great fixer' and would-be agent, talking us into various places just to take a photograph. I am grateful to all three for their patience and interest.

My thanks to my Maxine, my wife, and to all those at Amberley, especially Sarah Flight.

Michael Rouse
Ely, September 2010